IMAGES
of America

PARK VIEW

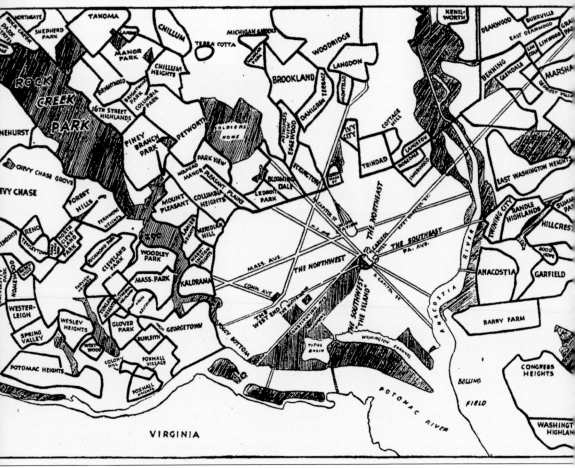

The *Washington Post* published this map in 1937. It shows the location of Park View with relationship to the surrounding neighborhoods. According to the 1921 *Directory and History of Park View*, "the territory comprising Park View extends from Gresham Street north to Rock Creek Church Road, and from Georgia Avenue to the Soldiers' Home grounds, including the triangle bounded by Park Road, Georgia Avenue, and New Hampshire Avenue." (The *Washington Post*.)

IMAGES
of America

PARK VIEW

Kent C. Boese
with Lauri Hafvenstein

ARCADIA
PUBLISHING

Published by Arcadia Publishing
Charleston, South Carolina

Printed in the United States of America

Library of Congress Control Number: 2010938201

For all general information, please contact Arcadia Publishing:
Telephone 843-853-2070
Fax 843-853-0044
E-mail sales@arcadiapublishing.com
For customer service and orders:
Toll-Free 1-888-313-2665

Visit us on the Internet at www.arcadiapublishing.com

CONTENTS

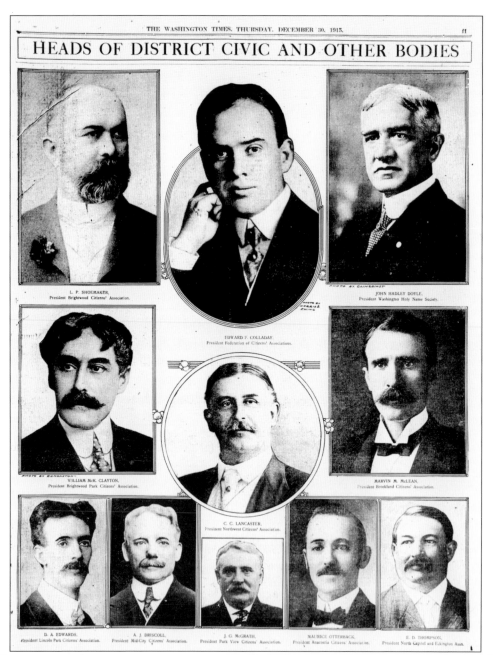

HEADS OF DISTRICT CIVIC AND OTHER BODIES

L. P. SHOEMAKER,
President Brightwood Citizens' Association.

EDWARD F. COLLADAY,
President Federation of Citizens' Associations.

JOHN HADLEY DOYLE,
President Washington Holy Name Society.

WILLIAM McK. CLAYTON,
President Brightwood Park Citizens' Association.

C. C. LANCASTER,
President Northwest Citizens' Association.

MARVIN M. McLEAN,
President Brookland Citizens' Association.

D. A. EDWARDS,
President Lincoln Park Citizens' Association.

A. J. DRISCOLL,
President Mid-City Citizens' Association.

J. G. McGRATH,
President Park View Citizens' Association.

MAURICE OTTERBACK,
President Anacostia Citizens' Association.

E. D. THOMPSON,
President North Capitol and Eckington Assn.

District citizens' associations were once a critical component in community organization and helped residents get their concerns before the three district commissioners who approved schools, roads, and other city improvements. The image above shows the heads of several civic groups in 1915, including Brightwood, Lincoln Park, and Anacostia. John G. McGrath, president of the Park View group, is shown at the bottom center. Organized in 1908, the Park View Citizens' Association's early successes included the paving of much of lower Georgia Avenue, the installation of streetlights, buried power lines, police call boxes, fire alarm boxes, and the extension of the city's fire limits. Partnering with other associations, Park View also worked to achieve better streetcar service. (*Washington Times*, Library of Congress.)

INTRODUCTION

The Park View neighborhood can trace its organization and name to March 1, 1908, when the Park View Citizens' Association first convened at the Whitney Avenue Christian Church on Park Road.

The neighborhood is situated on Georgia Avenue, one of the oldest routes in and out of the city and along the route that President Lincoln took when commuting to and from the White House from the nearby Soldiers' Home, which he used as a retreat from official Washington.

Citizens' associations were the only real voice that residents had in early-20th-century Washington, and the one in Park View was no exception. Park View's organizers were a strongly spirited group that took great pride in themselves and their city. The Park View Citizens' Association was instrumental in the success of the neighborhood, and its leaders worked hard to improve area streets, city services, and schools. By working closely with the three-member board of commissioners that was established to govern the District in 1874, and by including as honorary members notable Washingtonians such as President Wilson's daughter Margaret and newspaper cartoonist Clifford K. Berryman, the citizens' association was able to accomplish much in a relatively short time. Important achievements include the successful lobbying and erection of the Park View School in 1916, the establishment of a post office in 1918, and commercial development along Georgia Avenue. Infrastructure was high on the list. The community also won and received paved streets, buried power lines, and new streetcar stops.

Politically, 1917 marked the first election held in the city since 1874, when John G. McGrath was elected as community secretary. The chief responsibility of the position was school oversight. Margaret Wilson, Washington commissioner Louis Brownlow, Congressman M. Clyde Kelly, and other notable persons attended the swearing-in ceremonies, adding significance to the event.

Established during a time when Washington's neighborhoods were segregated, Park View's color barrier officially ended in 1948, when the Supreme Court ruled that the racially restrictive covenants were unconstitutional and could not be enforced. Families of African Americans increasingly began to call Park View home, and the neighborhood by the end of the 1950s flourished as a solidly African American community.

In 1968, the civil unrest that followed the assassination of Dr. Martin Luther King Jr. set in motion a period of gradual decline for Georgia Avenue. Many stores were looted and burned in the riots, and although some businesses rebuilt, many did not. The fabric of the Park View neighborhood was further eroded by the advent of crack cocaine and the encroachment of drug culture in the 1980s.

The opening of two Washington Metropolitan Area Transit Authority Metro stations in the vicinity of Park View in 1999 marked a turning point for the neighborhood. Park View began to slowly rebound as the city increasingly addressed area crime. Houses that had long been vacant began to be purchased, renovated, and occupied.

The Park View community today is diverse, with residents from many backgrounds and cultures. This cultural richness is celebrated each year when Park View, Petworth, and Pleasant Plains all play host to the D.C. Caribbean Carnival—a Caribbean-style parade and festival designed to encourage cross-cultural programs.

One

COUNTRY ESTATES,
LEISURE LIVING, AND WAR
19TH-CENTURY LIFE ALONG THE
SEVENTH STREET TURNPIKE

Park View was completely different in the 19th century. Instead of streets lined with tightly packed row houses, the area was rural with open fields and country homes. However, when compared to the surrounding countryside, it was well developed.

Located along the Seventh Street Turnpike, the area between Rock Creek Church Road and Howard University supported a cluster of country homes that formed a rural community north of the city. Schuetzen Park, a center of German culture, provided amusement for people living nearby, as well as visitors from the city to the south.

The existence of the nearby Soldiers' Home added the prestige of an occasional presidential presence. The nearby Soldiers' Home played a large role in defining the area. Presidents from James Buchanan to Chester A. Arthur spent summers there. The home's presence was particularly felt during the Civil War. Not only would President Lincoln travel frequently through the area, but also the increased activity of soldiers encamping nearby or traveling to Fort Stevens and the other forts defending the city made a definite impact on residents by bringing the war to their doorsteps. The location of nearby hospitals, such as Harewood, also brought home some of the war's horrors.

As the 19th century waned, the area was poised for urban development. With the closing of Schuetzen Park, the subdivision of the Asa Whitney estate, and the sale to the Soldiers' Home of Corcoran's Harewood, the era of rural life was coming to a close. The next century would see the rise of a neighborhood fully engaged in determining its destiny.

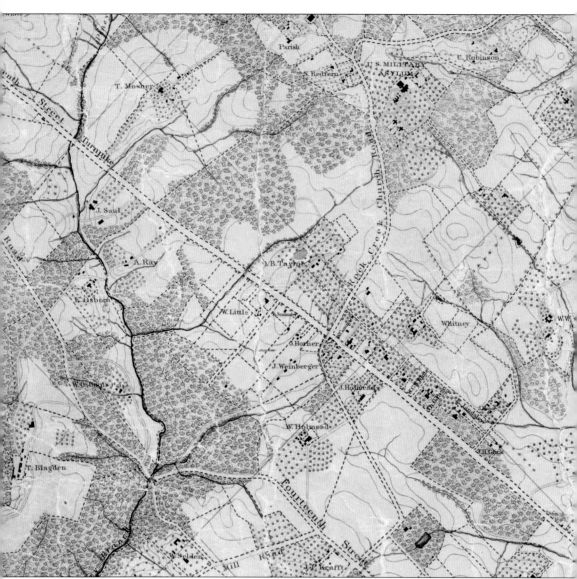

This 1861 map by Boschke shows the area that became Park View in Washington County, outside the boundaries of Washington City. Situated on some of the District's highest ground, it benefited from both its location along the Seventh Street Turnpike (the long diagonal road running from lower center to the upper left corner) and its short distance from Washington. The desirability of this section led to its early development as country estates for prominent Washingtonians

seeking to escape Washington's summer heat. Directly along the Seventh Street Turnpike were smaller estates, starting with John H. Glick's property, just south of today's Hobart Street to Rock Creek Church Road on the north, which marked the extent of the Cammack estate. (Library of Congress.)

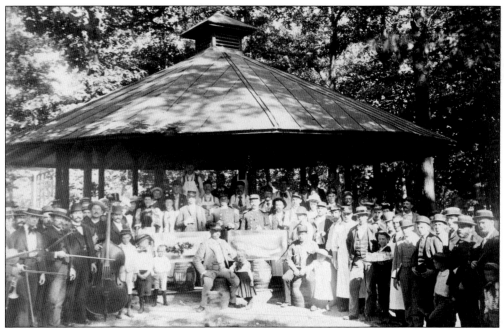

Schuetzen Park, located between today's Hobart and Kenyon Streets, opened at the close of the Civil War and continued to attract visitors until the 1891 ban on the sale of alcohol within a mile of the Soldiers' Home, which forced it to close. Shown here is a group of picnickers and musicians around 1890. The Seventh Street Turnpike was sparsely populated during its heyday. Among those living nearby were several prosperous German families—principally butchers in the Central Market downtown—including the Widmayers, Ebels, and Glicks. (Historical Society of Washington, D.C.)

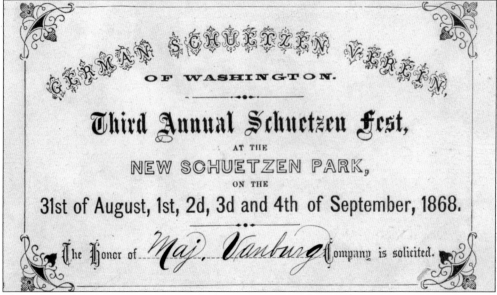

GERMAN SCHUETZEN VEREIN,

OF WASHINGTON.

Third Annual Schuetzen Fest,

AT THE

NEW SCHUETZEN PARK,

ON THE

31st of August, 1st, 2d, 3d and 4th of September, 1868.

The Honor of _Maj. Vanburg_ Company is solicited.

The Schuetzen Fest was a summer event known to attract thousands. A description of the 1867 event reported that 3,000 single-admission tickets had been sold with just as many membership and season ticket holders in attendance. In addition to target shooting contests and other amusements, attendees enjoyed drinking and camaraderie. (Historical Society of Washington, D.C.)

Fire destroyed Schuetzen Park on November 6, 1879, damaging many of the ground's large oak trees. On January 6, 1880, the formal cornerstone ceremonies commenced for the new Washington Schuetzen Building. It was not long before the Schuetzen Fest was again in full swing. The foremost German families in the city, as well as members of Congress, cabinet members, and the diplomatic corps, attended the park. (Historical Society of Washington, D.C.)

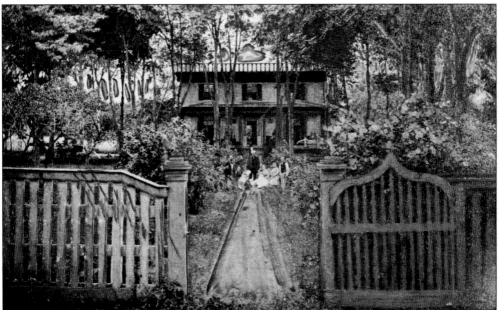

Located north of Park Road on Georgia Avenue was Stewart James Gass's estate, Glen May. Born around 1838, Gass purchased the property in 1855. The house dated to 1840, making it the earliest home in the area. The original entrance to the estate was at the northeast corner of Park Road and Georgia Avenue, where a winding road led up to the home. (Historical Society of Washington, D.C.)

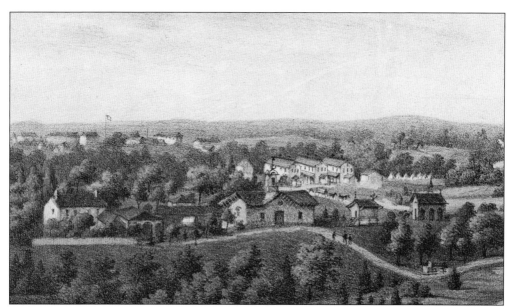

In 1852, William Wilson Corcoran purchased 191 acres for a country estate east of the Seventh Street Turnpike (Georgia Avenue) and north of what is today McMillan Reservoir (see page 126). He named it Harewood due to the number of rabbits located on the property. Corcoran had John Saul lay out the grounds and employed James Renwick to design the hunting lodge. The entire estate was purchased by the Old Soldiers' Home in 1872 and added to their grounds. (Harry T. Peters "America on Stone" Collection, National Museum of American History, Smithsonian Institution.)

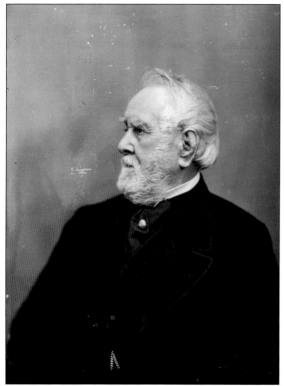

Corcoran (1798–1888) was a lifelong Washingtonian. He entered business at the age of 17 and subsequently failed in the depression of 1823. In 1828, he took control of his father's real estate holdings. Corcoran is mostly noted for his banking, philanthropic, and art-collecting interests. He entered into a partnership with George Washington Riggs in 1840, which prospered and became Riggs and Company upon Corcoran's retirement in 1854. Among his better-known legacies are the art museum and college of art and design that bear his name. (Library of Congress.)

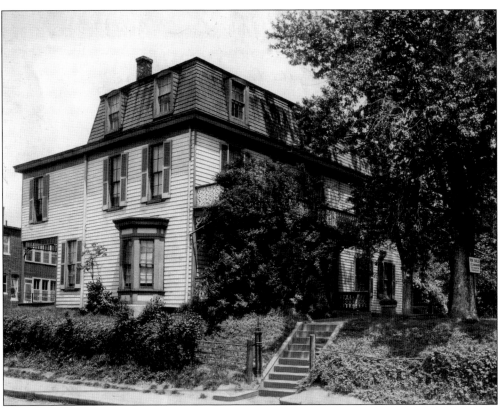

Locust Hill was the home of Asa Whitney (1797–1872). It was the largest estate in the area that became Park View proper. The home, now long gone, was located at 3543 Warder Street. Whitney Avenue took its name from him but was renamed Park Road in 1905. Just when Whitney first came to Washington is not certain, though he was established at Locust Hill by 1862. (Historical Society of Washington, D.C.)

Upon Asa Whitney's death, his wife, Catherine, continued to live at Locust Hill with two of her sisters. In 1886, the 43-acre estate was sold to B. H. Warder (c. 1825–1894), who proceeded to subdivide the property under the name Whitney Close. Today's Warder Street honors him. Though the subdivision was laid out in the 1880s, much of the land was not improved until Washington's housing boom in the early 20th century. (Library of Congress.)

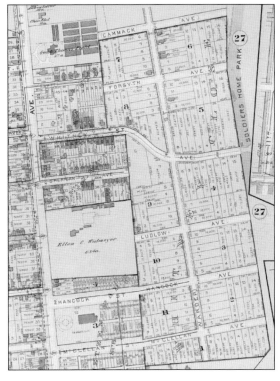

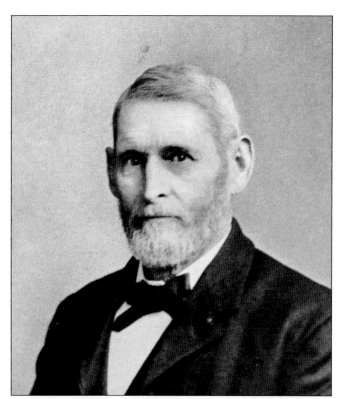

John Cammack (1828–1909) came from one of Washington's oldest families. Cammack maintained the family homestead at 3553 Brightwood Avenue (now Georgia Avenue). The estate was the center of a thriving floriculture business that his father had started with greenhouses in multiple Washington locations. Cammack had extensive real estate holdings and strong connections with several Washington banks. He was also the director and the largest major stockholder in both the Metropolitan and the Columbian Street Railways before they merged with the Washington Railway and Electric Company. (The *Washington Post*.)

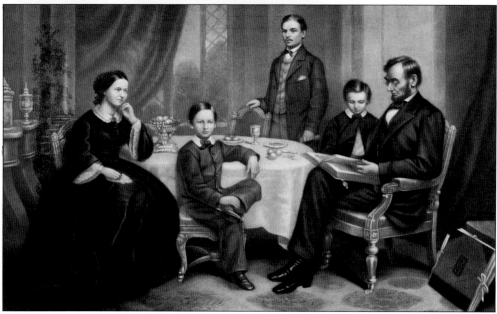

President Lincoln's family were the area's most distinguished residents from June through November, 1862 through 1864. His wife, Mary, and son Thomas "Tad" spent the warmer months of the year at the Soldiers' Home's Anderson cottage (see page 118), which was once owned by George Washington Riggs. During these months, Lincoln regularly traveled the 3-mile distance to and from his office at the White House. (Library of Congress.)

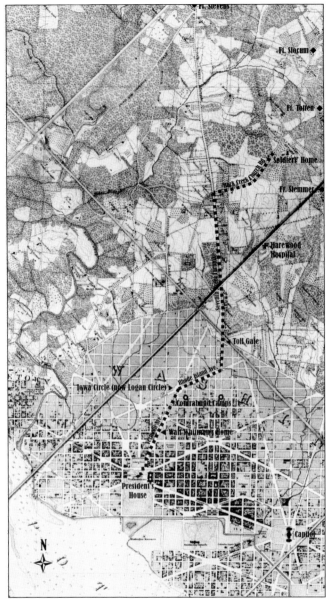

President Lincoln's commute from the Soldiers' Home to the White House and back required him to travel south and west on Rock Creek Church Road, where he would turn onto the Seventh Street Turnpike and ride south into the city. He would continue south on Seventh Street until it intersected with Rhode Island Avenue. Lincoln would next travel southwest on Rhode Island Avenue to Iowa Circle (now Logan Circle), which was where the route would then veer onto Vermont Avenue, leading to Lafayette Square and the White House. This route would be retraced as Lincoln returned to the country each evening. It was on one of these nighttime return trips to the Soldiers' Home in August 1864 that the president was fired upon in an assassination attempt. This was roughly in the vicinity of Georgia Avenue and Rock Creek Church Road. The military detail at the Soldiers' Home heard the shot and soon encountered a bareheaded Lincoln racing to safety. Soldiers reportedly took off down the road after hearing the shot and discovered Lincoln's iconic hat with a hole in it. (Lincoln's Cottage, a National Trust Historic Site.)

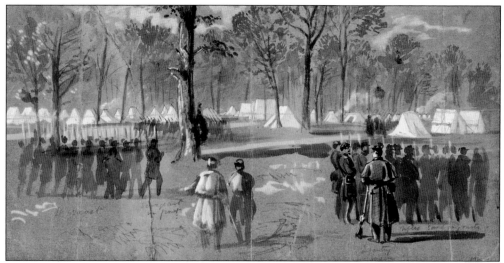

The 2nd Connecticut Regiment was encamped in a grove on the north side of the city during the Civil War. Some consider the site to be the land that soon afterward became Schuetzen Park. Artist Alfred R. Waud drew this image between May 20 and 23, 1861. Soldiers were also encamped on the properties of Stuart Gass (see page 13) and Frank May. May's property was on the east side of Georgia Avenue, between today's Morton Street and Park Road. (Library of Congress.)

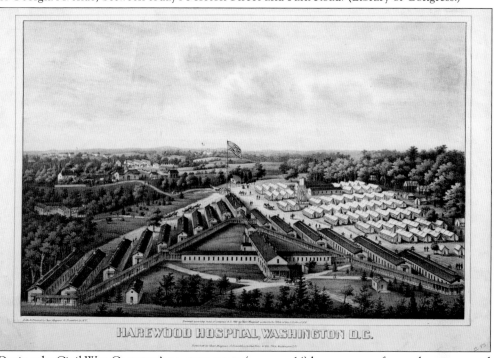

During the Civil War, Corcoran's country estate (see page 14) became one of many locations used as a hospital tending to the war's wounded. Harewood Hospital, which operated between September 1862 and May 1866, consisted of makeshift frame wards and tents. In this image, Harewood is seen from the south. The Soldiers' Home can be seen in the distance, and Corcoran's farm buildings are to the immediate northwest of the hospital. (Harry T. Peters "America on Stone" Collection, National Museum of American History, Smithsonian Institution.)

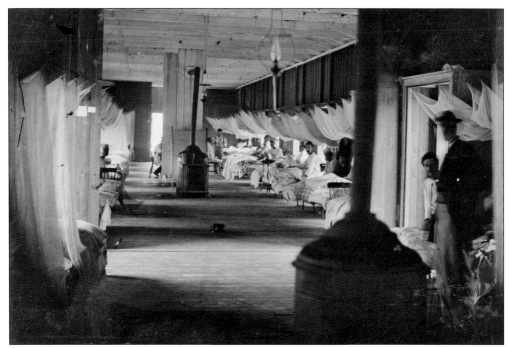

The need to care for the sick and wounded became increasingly important. Hospitals located near the Seventh Street Turnpike included Harewood (pictured here) and Campbell Hospital to the southwest. Hospitals averaged 500 beds. Most buildings had no heat or ventilation. Harewood began as a series of tents and was soon surrounded by refuse and excrement. This resulted in mosquitoes and flies spreading malaria and transporting other diseases. Most Washington hospitals were equipped with mosquito netting, but patients, like those in the photograph above, found the netting hot and uncomfortable and would seldom keep it in place. Not all hospital life was grim. A band in front of Harewood's officers' quarters in April 1864 can be seen in the image below. (Both, Library of Congress.)

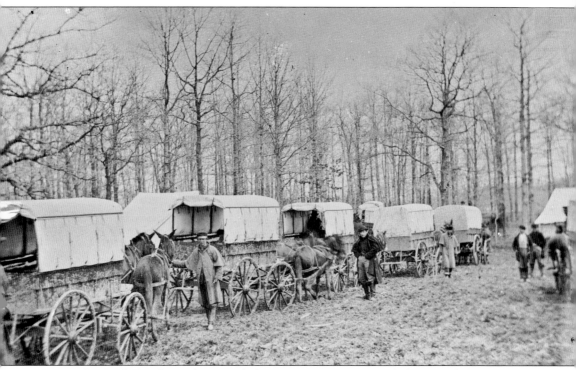

During the Civil War, horse-drawn ambulance caravans transported the wounded to hospitals and facilities that sprang up throughout the District to tend to those in need. Such caravans would have been a familiar sight to those who lived and relied on the Seventh Street Turnpike. According to a contemporary account in the *New York Tribune*, President Lincoln met such a caravan on July 4, 1862, during one of his commutes and rode along with the wagon train talking to the soldiers. (Library of Congress.)

Two

Constructing a Neighborhood
Developers, Builders, and Washington's Housing Boom

The rise of Park View as a neighborhood dates to 1886, when B. H. Warder purchased the former 20-acre estate of Asa Whitney and subdivided the property into Whitney Close. While actual development was initially slow, the areas and subdivisions along Georgia Avenue were among the first to see single-family residences constructed.

By 1904, however, a strong economy, an ever-decreasing availability of near-in land, and large public green spaces, such as the Soldiers' Home and the McMillan Reservoir, all set the stage for Park View to finally take off. Street after street eventually filled in with homes designed by architects A. H. Beers, N. T. Haller, and others.

Most construction projects were smaller in scale, with many builders completing rows of 4 to 10 homes at a time. Harry Wardman, Edgar S. Kennedy, and Herman R. Howenstein were exceptions. These developers left permanent and recognizable marks on the community.

Wardman's contribution to Park View dates to 1909 and 1910 with homes located on Keefer Place, Lamont Street, and Georgia Avenue. Also starting in 1909 and continuing until 1917 was the even larger development by Kennedy, who constructed 162 contiguous homes in 20 separate rows between Georgia Avenue and Park Place south of Rock Creek Church Road. Following World War I, Howenstein filled in most of the remaining undeveloped land with 135 homes largely located on Princeton, Park, and Otis Places.

With the neighborhood built out, it experienced a period of relative calm, only to be upset as a result of urban renewal in the 1960s. The District's decision to redevelop nearly all of Southwest Washington, D.C., displaced thousands of people. In order to house many displaced families, the D.C. Housing Authority built housing complexes across the city, often by razing entire blocks of existing houses. Park View's Park Morton development is one such example.

This April 1960 image shows some of Park View's earliest homes. This part of Park View originally belonged to Frank P. May, whose estate was called Bellevue. The houses in the distance at 636 to 640 Park Road were designed by Fredrick G. Atkinson and built by Atkinson and Sherwood in 1895. To the east (right) of them, at 642 and 644 Park Road, were two houses built by James T. Levy in 1893. Fred A. Volland built the residence at 646 Park Road in 1896. Just to the east, at 648 Park Road, was a residence designed by Ferdinand G. Purner and built by O. W. Niedomanski in 1899. The commercial building in the foreground was added in 1911. With the exception of 646, 648, and 650 Park Road, these houses were all razed to make way for the Park Morton housing complex (see page 40). (D.C. Housing Authority.)

While Asa Whitney's estate (see page 15) was the first such property to be subdivided, the first to be actively promoted was the subdivision of the Glick estate, located on the northern boundary of Howard University, in 1904. Advertisements noted the Glick lots' desirable location near the high-priced properties in the northwest, yet the Glick Lots were advantageously closer to Washington's business center than the high-priced properties. Unimproved lots sold for prices beginning at $300. (*Washington Times*, Library of Congress.)

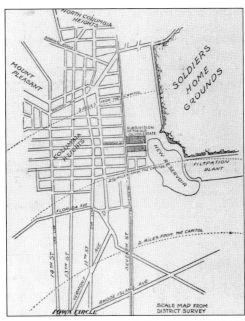

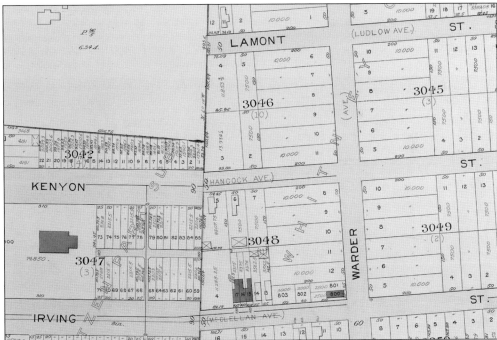

When development began north of Boundary Street (renamed Florida Avenue in 1890) in the 19th century, it was outside of Washington's city limits. Communities such as LeDroit Park or Columbia Heights were considered to be self-contained suburbs of Washington. As such, each had their own naming convention for their streets. In 1905, significantly after Washington City and County were combined in 1871, the Commissioners of the District of Columbia focused on renaming the outlying streets to conform to the naming system used by the old city. As can be seen on the map detail above, a few of the names that changed in Park View were Ludlow Avenue (Lamont), Hancock Avenue (Kenyon), and McClellan Avenue (Irving). (Library of Congress.)

The houses between 441 and 453 Lamont Street were designed by N. T. Haller for builder William M. Gain. These brick Colonial houses were among the first in the area with hot-water heat. (*Washington Times*, Library of Congress.)

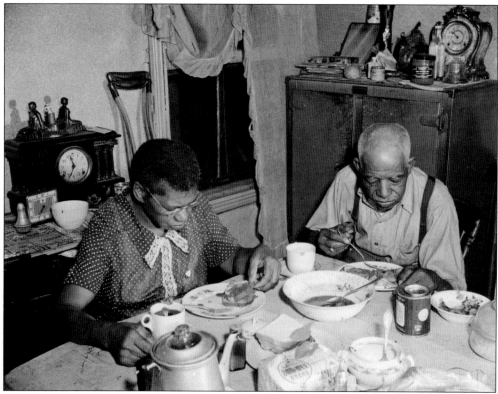

This photograph by Gordon Parks shows an elderly couple eating dinner at their home on an unidentified block of Lamont Street. It was taken in June 1942 as part of the Farm Security Administration's landmark project to document Americans and the effects of the Great Depression. (Library of Congress.)

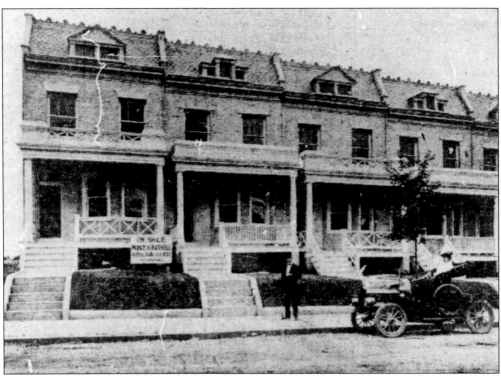

N. T. Haller designed the row of houses at 592 to 600 Park Road in 1908 for builder Percy H. Russell. The real estate advertisement offering these houses to the public stated that one of their many advantages was "one of the most beautiful parks in the world— SOLDIERS' HOME—containing over 500 acres of land, which is yours without the care or expense of paying taxes, if you are 'LUCKY' enough to own one of these houses." (*Washington Times*, Library of Congress.)

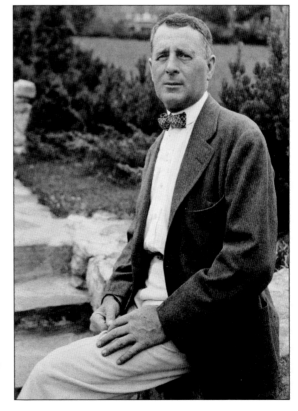

Harry Wardman (1872–1938) was a young tradesman when he moved to Washington in 1895. By the beginning of the 20th century, he was well on his way to becoming one of Washington's more dominant figures in real estate. During his 35-year career, Wardman built an estimated 9,000 houses, more than 400 apartment buildings, and half a dozen major hotels. (Library of Congress.)

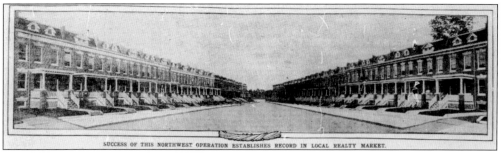

Wardman's contributions to Park View are on Keefer Place and Lamont Streets, with a few on Georgia Avenue. Wardman's 50 houses on Keefer Place were completed and sold in less than six months, the *Washington Times* reported in December 1909. The houses were designed by architect A. H. Beers and largely used Flemish bond and red pressed brick. These houses were moderately priced at $3,750. (*Washington Times*, Library of Congress.)

Shannon and Luchs was Wardman's exclusive real estate agent. This advertisement from 1910, promoting the value and quality of the houses, was directed toward moderate-income families. The advertisement states that a similar house would sell for more than $4,200 as opposed to $3,750 for these houses. The price probably explains why 80 of the houses sold in less than one year. (*Washington Herald*, Library of Congress.)

Adjoining the Soldiers' Home Park, the houses at 435 to 453 Irving Street were designed by architect N. T. Haller for builder George P. Newton. Similar to other Haller designs, they were in the Colonial style. To take advantage of their proximity to the park, each had a massive porch as well as a good-sized yard. (*Washington Times*, Library of Congress.)

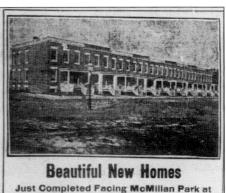

The houses located between 601 and 625 Rock Creek Church Road were designed by A. H. Beers and built by Zepp Brothers in 1909. Though there were many modest new houses for buyers to choose from at the time, buyers complained that few combined convenience, comfort, and beauty. Zepp Brothers attempted to address these complaints by including every up-to-date feature and more architectural beauty than was found in competing houses. (*Washington Times*, Library of Congress.)

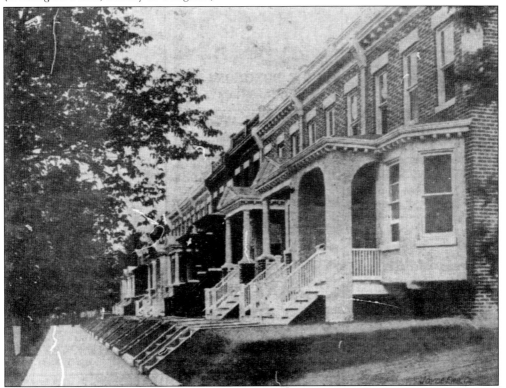

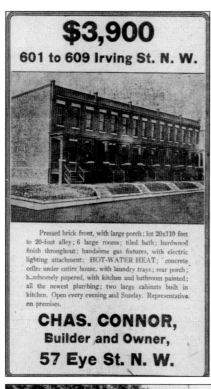

$3,900

601 to 609 Irving St. N. W.

Pressed brick front, with large porch; lot 20x110 feet to 20-foot alley; 6 large rooms; tiled bath; hardwood finish throughout; handsome gas fixtures, with electric lighting attachment; HOT-WATER HEAT; concrete cellar under entire house, with laundry trays; rear porch; handsomely papered, with kitchen and bathroom painted; all the newest plumbing; two large cabinets built in kitchen. Open every evening and Sunday. Representative on premises.

CHAS. CONNOR,
Builder and Owner,
57 Eye St. N. W.

Builder Charles Connor's contribution to the neighborhood consisted of the pressed-brick houses located at 601 to 609 Irving Street, which were completed and on the market by July 1910. Typical of the period, the houses contained six rooms and were outfitted with gas light fixtures that contained electric lighting attachments. The inclusion of hot-water heat was prominently featured in advertisements attracting buyers. (*Washington Herald*, Library of Congress.)

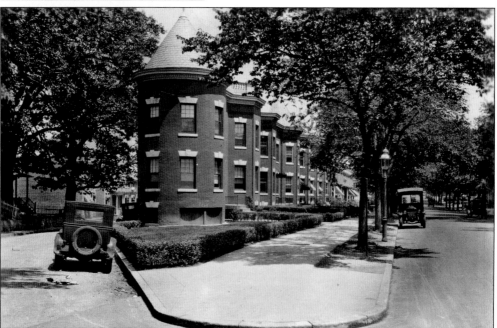

The homes on the west side of New Hampshire Avenue from 3600 to 3612 were built by Joseph J. Moebs in 1909. Upon purchasing the land from Ernest Steiger for $7,800, some speculated that Moebs would erect an apartment house instead. This view dates to 1927 and shows the row from the southeast, at the intersection of New Hampshire and Rock Creek Church Road. (Historical Society of Washington, D.C.)

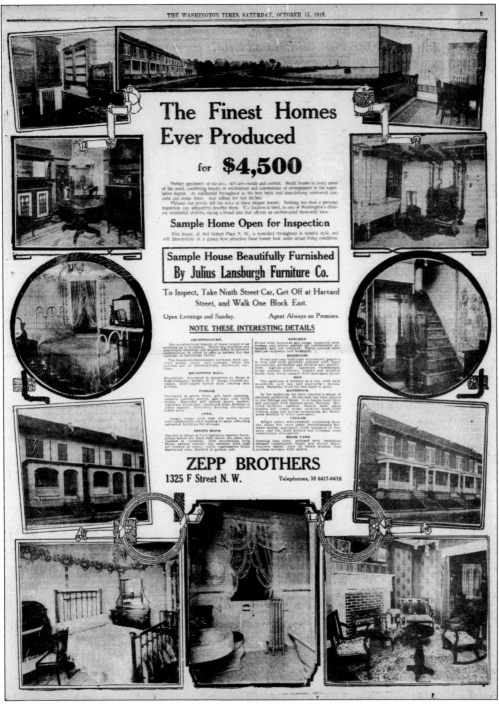

This full-page advertisement from October 1910 describes these Zepp Brothers houses on Hobart Place as perfect specimens of the architect's art, both inside and out. The Julius Lansburgh Furniture Company furnished the model house. The advertisement stated that the ideal location in one of "Washington's choicest residential sections" had an unobstructed 3-mile view across the McMillan Reservoir. (*Washington Times*, Library of Congress.)

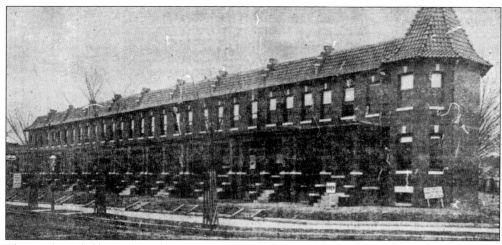

The area bounded by Park Road, Georgia Avenue, and New Hampshire Avenue was first subdivided by Ernest Steiger of New York and Mason L. Weems, founder of the Weems line of steamers running between Washington and Baltimore. The properties were held intact until the rapidly expanding city reached their limits. In 1910, building commenced with the erection of Spanish-style houses by Walter A. Dunigan that sold for between $5,000 and $6,500. (*Washington Times*, Library of Congress.)

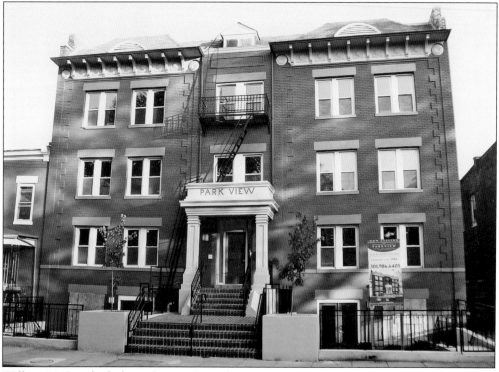

William M. Gain built the Park View, located at 610 Irving Street, from designs by the N. T. Haller Company. The estimated cost of the project was $35,000. The 16-unit building was completed by August 21, 1910. This was reportedly the first apartment house in the city to include a shared laundry facility for its tenants. Apartments consisted of four- and five-room suites and rented from $20 to $25 per month. Pictured above in 2009, the apartments were converted to condominiums that listed for over $200,000 each. (Photograph by Kent Boese.)

Middaugh and Shannon constructed the 12 houses at 431–453 Newton Place using designs from architect Claughton West. They proudly promoted their houses by showing images of the interiors, rather than the facades, as other developers commonly did. By doing so, they hoped to convey houses of sunlight and ventilation, with artistic interior arrangements. (*Washington Herald*, Library of Congress.)

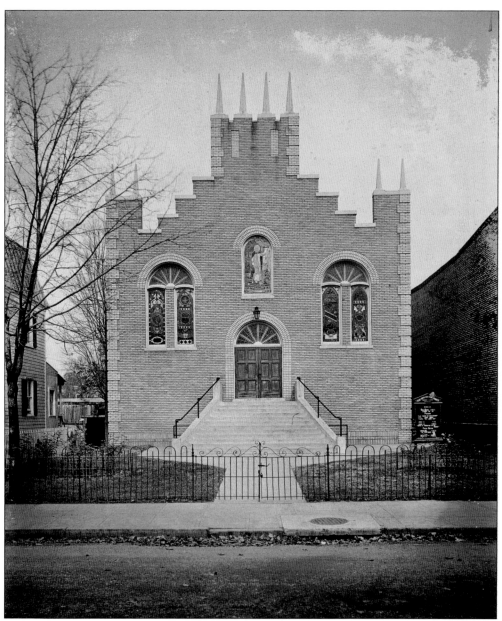

This modern classic church at 625 Park Road, constructed at an estimated cost of $30,000, was built in 1920 to replace the Whitney Avenue Christian Church. The latter had been built in 1877, making it one of the oldest landmarks in Park View at that time. At the time of its completion, the church's name was changed to Park View Christian Church. After the congregation moved to Shepherd Park in 1944, this became the Trinity African Methodist Episcopal (A.M.E.) Zion Church, under the direction of Rev. William R. Jones. Trinity A.M.E. Zion was located on Park Road for just under 40 years, moving to 3505 Sixteenth Street, NW, in 1983. Between 1983 and 1995, the Greater Mount Calvary Holy Church used this building to support its congregation until it moved to 610 Rhode Island Avenue, NE. Since 1995, the New Commandment Baptist Church has called 625 Park Road home, having purchased the structure from Greater Mount Calvary Church that year for $600,000. (Library of Congress.)

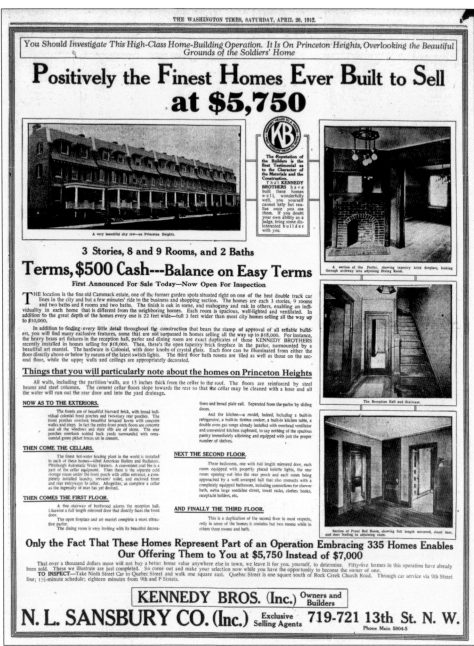

Edgar S. Kennedy first came to Washington in 1884 and went into the building business. He quickly established himself in the firm of Kennedy and Davis in 1886. Upon Davis's death in 1905, Kennedy's brother William became involved as general manager, and the name was formally changed to Kennedy Brothers, Inc., in 1909. Kennedy was already well known for building quality houses in Mount Pleasant and Capitol Hill when he secured the former Cammack estate (see page 16). The row of houses in this 1912 advertisement is located on Quebec Place. To attract buyers, the advertisement leads with the following description: "The location is the fine old Cammack estate, one of the former garden spots situated right on one of the best double-track car lines in the city." (*Washington Times*, Library of Congress.)

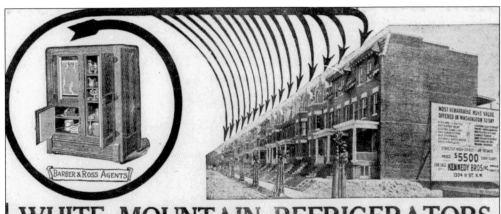

It is impossible to know if Kennedy's choice of White Mountain Refrigerators actually helped sell his houses on Rock Creek Church Road, as this 1910 advertisement claims. It is clear, however, that retailers considered Kennedy homes desirable enough that any association of their products with them would help sell their wares. (*Washington Times*, Library of Congress.)

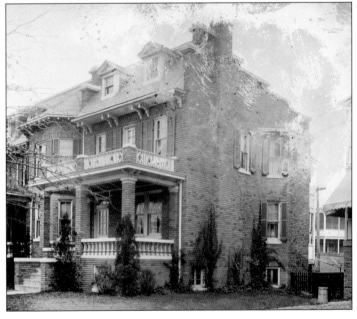

A 1916 *Washington Post* article listed the many novel features that were planned by Kennedy Brothers in the seven row houses at 3644–3654 Park Place and 608 Rock Creek Church Road. Among the innovations were ample front lawns and attached, fireproof garages, a first for Park View and the only such row constructed by Kennedy in the neighborhood. The two-story dwellings were constructed of gray tapestry brick with green and gray slate roofs. (Library of Congress.)

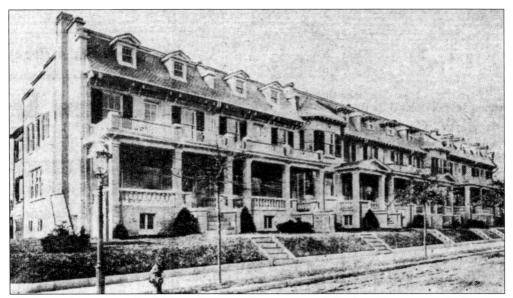

This row of houses on Park Place, between Princeton and Quebec Places, was the last row constructed by Edgar S. Kennedy in his Princeton Heights subdivision. They were advertised in January 1917 as being high-class houses that contained eight rooms, an attic, and two bathrooms. The units on the ends contained built-in garages. Other advertised details were oak trimming and floors, electrical lighting, and hot-water heat. (The *Washington Post*.)

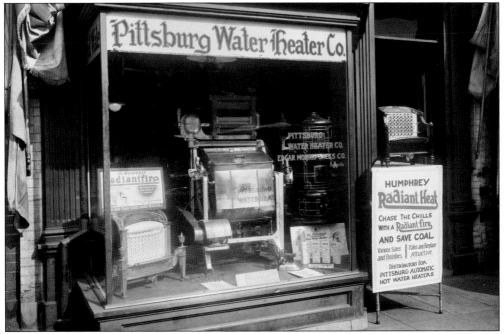

New conveniences that were included in many new houses at the time were Pittsburg Water Heaters and Humphrey Radiant Fire gas heaters, pictured here around 1921. No fewer than four Park View builders emphasized the modernity of their houses by listing such innovations. Another modern appliance available to homeowners at the time was the Apex Electric Washing Machine, also pictured above. (Library of Congress.)

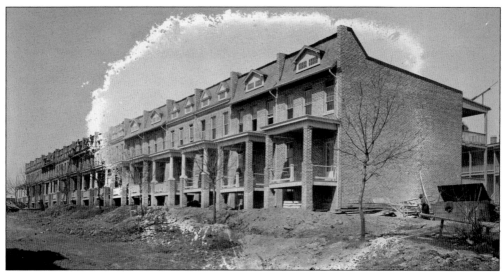

The United States' entry into World War I ended Kennedy's development of the Cammack property, with the exceptions being the York Theater and an apartment building on Georgia Avenue. When construction resumed in 1919, it was at the hands of Herman R. Howenstein (c. 1877–1955). Howenstein purchased the remainder of the land, including all of Princeton Place, located between Georgia Avenue and Park Place south to the north side of Otis Place. In 1919, Howenstein began to build 135 new houses in this development, making it among the largest building enterprises of that year. Above is 605–637 Otis Place shortly after completion. (Library of Congress.)

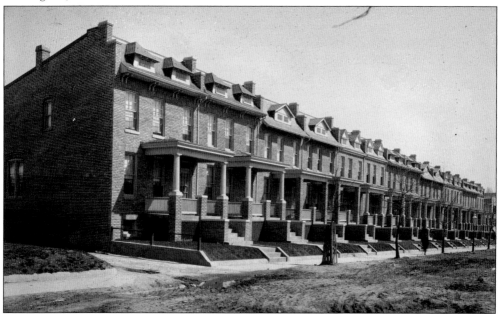

Unlike the earlier Kennedy houses, just to the north of this row at 609–637 Princeton Place, Howenstein's designs were more static and consisted of a single row, using congruous materials from house to house. Still, some variation was incorporated within each row. This is most apparent in the styles and types of dormers constructed and the choice of column supports used on the front porches. (Library of Congress.)

This unit, 717 Princeton Place, belongs to a row of five homes, starting with 709 Princeton Place, built by Herman R. Howenstein in 1920. This photograph dates to the fall of 1920, shortly before ground was broken for the adjoining row. This image captures a brief moment between phases in what now appears to be one contiguous row of houses along Princeton Place. It also offers a glimpse as to what the rear facade of the Kennedy Brothers houses on Quebec Place looked like at the time. (Library of Congress.)

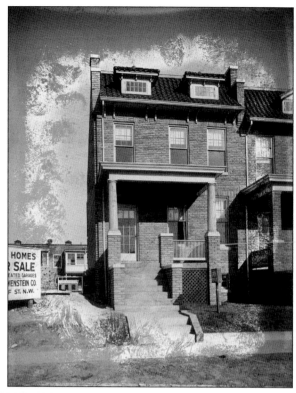

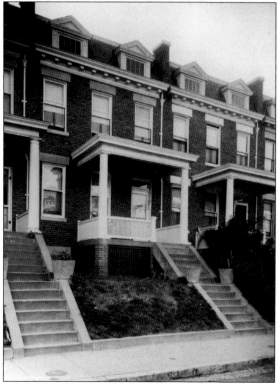

These houses belong to a row designed by architects Hunter and Bell for builder William S. Phillips and completed in 1915. They can be found on the west side of Warder Street between 3200 and 3214. (Library of Congress.)

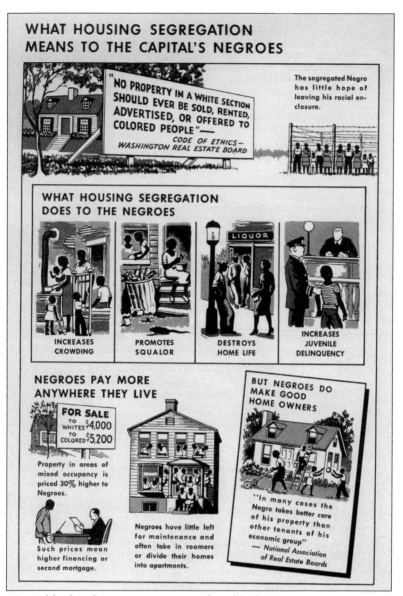

Washington's neighborhoods were once segregated, and Park View was no exception. Established as a white neighborhood, Park View maintained its community ethnicity in a variety of ways. The most prevalent was the use of restrictive covenants. Covenants were agreements not to sell to certain types of people and were only enforceable through the courts. Park View began to diversify in the 1930s, with black Washingtonians moving into housing nearer to Howard University on Gresham Street, Columbia Road, and Irving Street. The practice of price gouging was another technique. In 1944, A. Walter Collier, president of the Park View Citizens' Association, noted that houses in the 400 block of Park Road that had sold for $3,800 in 1914 were now being sold to black families for $9,000. The illustration here is from *Segregation in Washington: A report of the National Committee on Segregation in the Nation's Capital* (1948) and shows that these were not isolated incidents or concerns. In 1948, the Supreme Court ruled that restrictive covenants were not enforceable. Within 10 years, Park View became a solidly African American community. (Author's collection.)

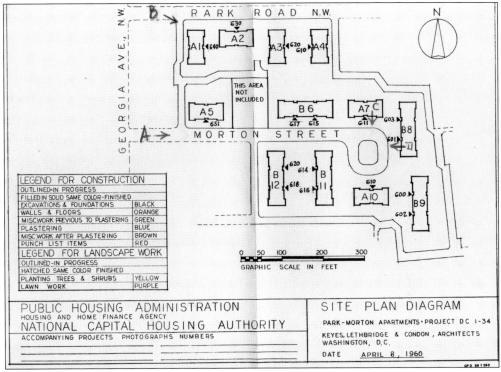

LEGEND FOR CONSTRUCTION
OUTLINED-IN PROGRESS
FILLED IN SOLID SAME COLOR-FINISHED
EXCAVATIONS & FOUNDATIONS | BLACK
WALLS & FLOORS | ORANGE
MISC.WORK PREVIOUS TO PLASTERING | GREEN
PLASTERING | BLUE
MISC. WORK AFTER PLASTERING | BROWN
PUNCH LIST ITEMS | RED
LEGEND FOR LANDSCAPE WORK
OUTLINED-IN PROGRESS
HATCHED SAME COLOR FINISHED
PLANTING TREES & SHRUBS | YELLOW
LAWN WORK | PURPLE

PUBLIC HOUSING ADMINISTRATION
HOUSING AND HOME FINANCE AGENCY
NATIONAL CAPITAL HOUSING AUTHORITY
ACCOMPANYING PROJECTS PHOTOGRAPHS NUMBERS

SITE PLAN DIAGRAM
PARK-MORTON APARTMENTS·PROJECT DC 1-34
KEYES, LETHBRIDGE & CONDON, ARCHITECTS
WASHINGTON, D.C.
DATE APRIL 8, 1960

Construction on the Park Morton public housing project began in May 1960. In April of that year, the Housing Authority voted to accept a bid of the Blake Construction Company to erect 12 buildings with 174 apartments that had 2 bedrooms each. Their bid was $1,698,000. A total of 12 firms—about three times more than usual—made bids for the contract. Blake's bid was $65,000 less than the second lowest bid. (D.C. Housing Authority.)

The 700 block of Morton Street, between Georgia and Sherman Avenues, was also considered as a possible site for the Park Morton housing development. This section was photographed around 1960 by the D.C. Housing Authority as part of its survey of Morton Street. (D.C. Housing Authority.)

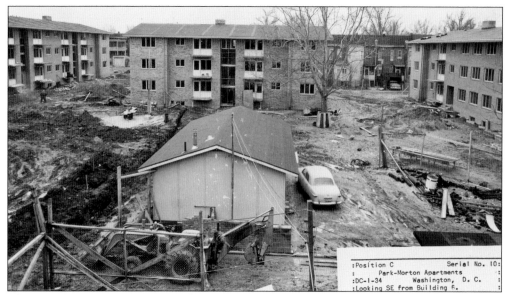

This March 1, 1961, image shows the progress of the Park Morton from the north side of the east end of Morton Street. This view to the south shows Lamont Street in the distance. (D.C. Housing Authority.)

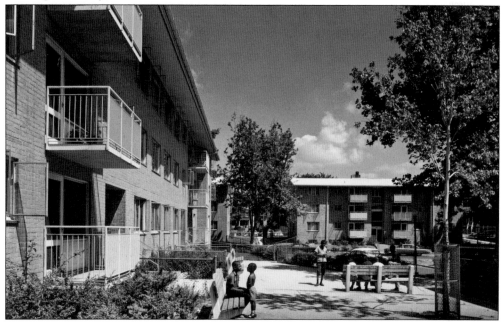

The Park Morton was designed by the firm of Keyes, Lethbridge, and Condon and was granted an award for architectural excellence by the Federal Public Housing Administration in 1964. In spite of this, the development received harsh criticism from the Comptroller General of the United States, who determined that the project would have been just as "decent, safe, and sanitary" without balconies. Each of the 174 apartments at the Park Morton has its own balcony, which the director of the National Capital Housing Authority, Walter E. Washington, considered to have "[added] immeasurably to the appearance, livability, and in the case of fire, to the safety of the buildings." (D.C. Housing Authority.)

Three

SCHOOLS AND EDUCATION
A UNIVERSAL THREAD UNITING THE GENERATIONS

Education and the need for an adequate school for area children was one of the earliest focuses of Park View residents. In 1908, the newly formed Park View Citizens' Association made a successful appeal to the U.S. Congress for funds to purchase land for school purposes. Funds to construct the school, however, were not as forthcoming.

Over the ensuing eight years, the community persisted in its need for construction funds. Among citizens' concerns were that the lack of a school facility forced many children to remain at home, which broke the truancy law. In 1912, the Park View Citizens' Association called for an appropriation of $130,000 to build a 16-room school at the corner of Warder and Newton Streets. Congress consistently ignored the community's appeals. While the District commissioners had included an item for $66,000 to erect a school in Park View in their 1910 and 1911 annual estimates sent to Congress, each time the item was stricken. To illustrate the need of the community, by 1912, a school census showed Park View to have 1,193 children. Most were then attending school in Petworth or being accommodated by portable schoolhouses on the site of the proposed school. Ultimately, the community prevailed.

The neighborhood's next battle was the name of the school. The District Board of Education recommended that the school be named "Lemon G. Hine School" in honor of the former District commissioner. The citizens, however, wanted the school named after the community. The District commissioners decided to grant the residents' request in recognition of the community's efforts to get a school.

Subsequent years continued to see a strong commitment to area education, with active Parent-Teacher Associations (PTAs) and an involved community. They expanded the school in 1931, updated the library in 1950, and persevered despite reduced school funding and the introduction of drug culture in the neighborhood. In 2010, education is again uppermost in the community's mind, as the combined Bruce-Monroe and Park View Schools are located in the historic structure, awaiting a decision on where their permanent structure will be located.

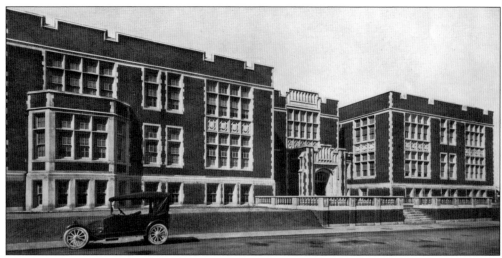

The Park View School, seen here about 1920, opened in October 1916 to much fanfare and a week of celebration that included an appearance by the District commissioners. Municipal architect Snowden Ashford designed it in the Collegiate Gothic style. The school's appearance is in keeping with other schools of the period, such as Central (Cardozo) High School (1916) and Eastern High School (1923). (Author's collection.)

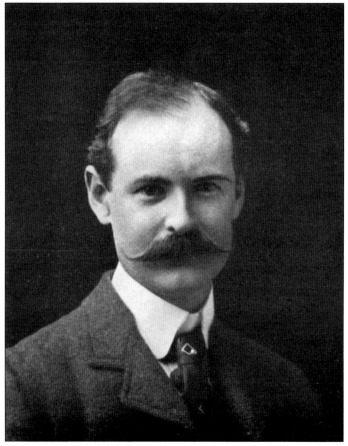

Snowden Ashford (1866–1927) was Washington's first municipal architect. Ashford designed or supervised everything the District built between 1895 and 1921, ranging from firehouses and police stations to the North Hall at the Eastern Market. He was particularly proud of his schools. By 1912, Ashford claimed more experience with schoolhouse work than any other architect in the country. During the opening ceremonies for Ashford's Park View School, he spoke of his efforts to enhance the health, eyesight, and safety of the children who would use the school. (The *Washington Post*.)

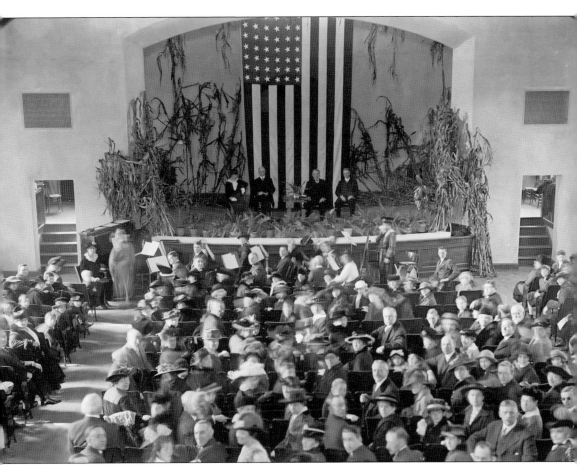

The first community Thanksgiving service in Washington, pictured here, was held in the Park View School auditorium on November 30, 1916, fulfilling the structure's purpose as both an educational facility and a community center. Special guests at the celebration were Margaret Wilson, daughter of the president, and Dr. Philander P. Claxton, U.S. commissioner of education. Margaret Wilson sang La Farge's "Homeward," and Dr. Claxton delivered an address advocating the more extensive use of school buildings as community centers. Dr. Claxton furthered that the essence of the American system was local self-government and that the larger use of the school buildings in Washington might lead toward self-government in the District. (Library of Congress.)

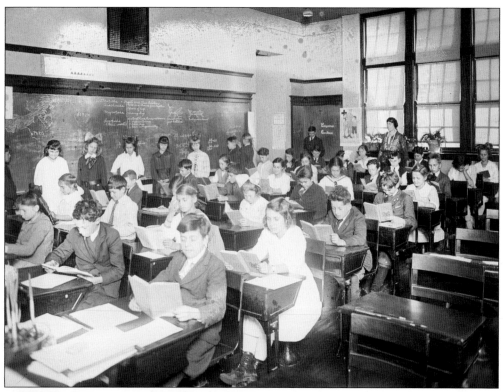

This photograph from about 1920 captures a typical classroom at the Park View School. (Library of Congress.)

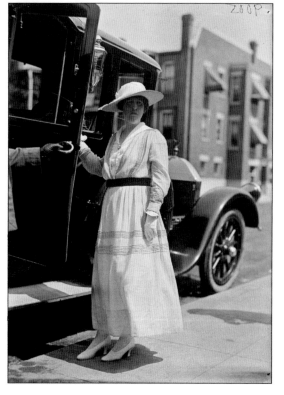

Margaret Wilson was a frequent participant in Park View events. She is photographed here in 1917 in front of the Park View School, preparing to get into the presidential limousine. (Library of Congress.)

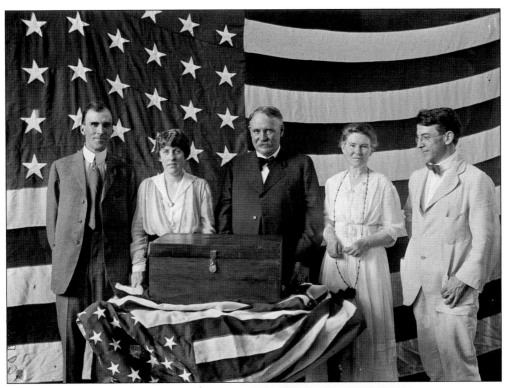

Photographed here on the evening of June 19, 1917, are the candidates for the Park View community secretary with guest Margaret Wilson (second from left) and John G. McGrath (center). This was the first District election since voting rights had been stripped in 1874. The community secretary was paid a salary by the District and administrated all community affairs under the Park View Citizens' Association. Out of 231 votes cast, John G. McGrath received 192. (Library of Congress.)

Congressman Charles B. Ward (1879–1946), photographed here in front of the Park View School in 1918, was elected to the House of Representatives in 1915 and served until 1925. He was likely part of that year's July Fourth celebrations, at which a new service flag honoring Park View citizens was unfurled and prominently hung at the school. (Library of Congress.)

In 1918, Park View became the first school in the country to provide postal service. John C. Koons (1873–1937), the first assistant postmaster general, was the guest of honor and orator at the dedication ceremonies. (Library of Congress.)

John G. McGrath, pictured here, was instrumental in getting the nationally important experiment in local postal service located at the Park View School. The Park View Post Office was dedicated on July 4, 1918, and located in the lower level of the building. (Library of Congress.)

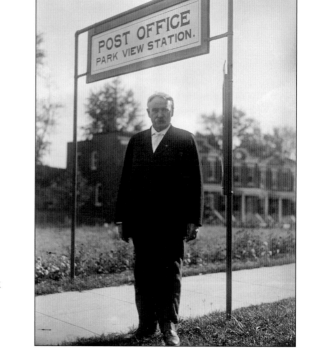

The installation of a post office within the Park View School enhanced the school's use as a community and recreation center. Photographed in 1918, John G. McGrath acts as postal clerk. (Library of Congress.)

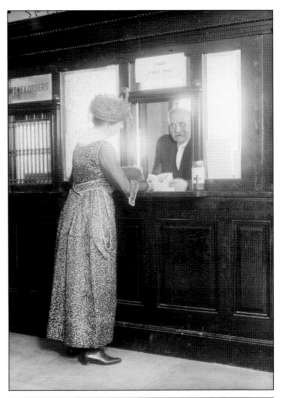

Attendance at the school quickly rose from 740 to 1,037 students, far exceeding the capacity of the building and necessitating the installation of three portable classrooms on the playground, seen here about 1920. The school instituted what was known as the "two-platoon" system to increase the number of classes that could be accommodated. The school was the only school in the District to adopt the platoon model. Additions to the rear of the structure containing 15 classrooms were completed and in use by 1931. (Library of Congress.)

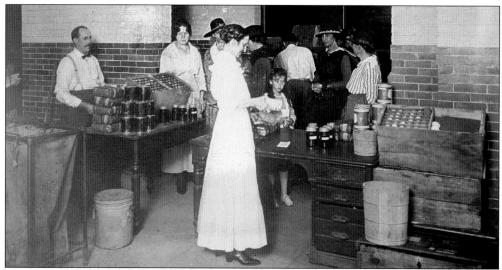

The country's entry into World War I impacted everyday life in a number of ways, such as increased food prices. In response, the community started a food cooperative in the school's basement in May 1917. By July 1919, the board of education had decided to discontinue the use of public schools for cooperative buying of foods but agreed to allow schools to continue selling army supplies. Inasmuch as no formal action had been taken by the board of education, the community center organization took no steps to put an end to the selling of foods in schoolhouse stores. Under the direction of John G. McGrath, the Park View School was the first in the District to work out community cooperative buying on a big scale, which at one time in the winter of 1918 reached the proportions of a $50,000-a-year business. Commodities were received in wholesale lots and sold at a saving to the consumers ranging from 15 to 25 percent. (Both, Library of Congress.)

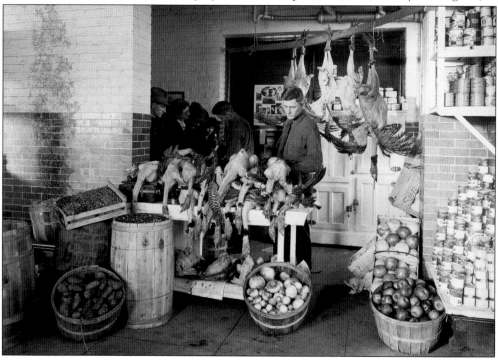

These children of the 5-A class at Park View Platoon School were photographed in 1927 while studying rubber. Local merchants loaned products made of rubber for use at the school. Pictured are, from left to right, (first row) Eleanor Wells, Eleanor Corbin, Ralph Borlik, May Beall Koogle, and Margaret Jonschard; (second row) Marian Talbert, Richard Lawlall, Francis Smith, Allen Henkin, and Dorothy Van Hise. (The *Washington Post.*)

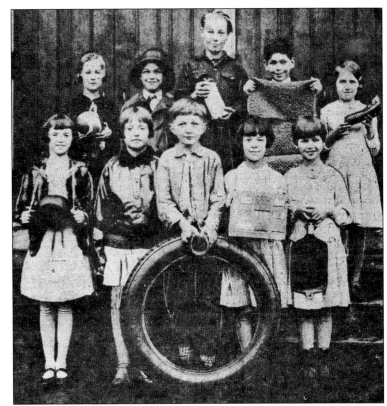

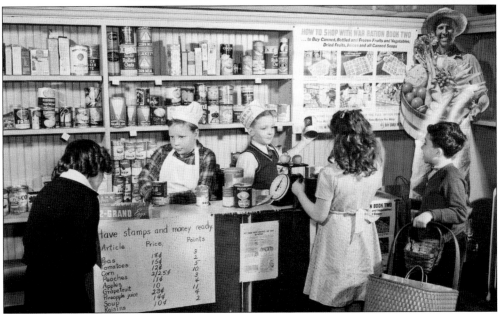

During World War II, buying canned and bottled foods with war ration books became real to pupils through the use of this model store set-up in a classroom in the Park View Elementary School. Referring to the posted list, pupils learned practical arithmetic when they figured both prices and points. This photograph was taken in February 1943. (Library of Congress.)

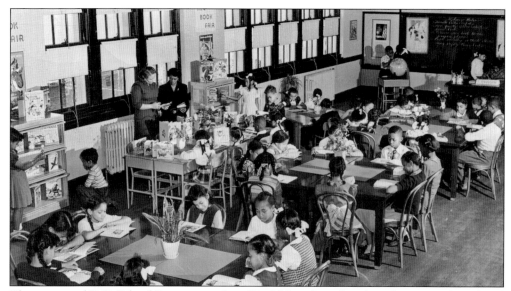

The segregated D.C. School System transferred Park View from the white division to the colored division in 1949. One of the school's earliest priorities was to establish a good library. Seen here in November 1950, students are observing Book Week by reading in the library. In conjunction with Book Week, Park View conducted a book fair. Parents contributed new books to the school during the fair, and one local bookstore loaned 50 books to make Book Week a success. (*Afro-American* Newspapers Archives and Research Center.)

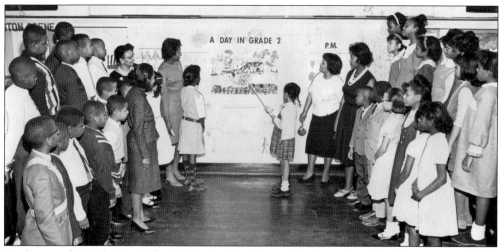

Students at the Park View School joined with other pupils throughout the District to mark the 1965 American Education Week. Shown here is the fifth-grade class of Annie A. Montgomery. Visiting parents and children watched second-grade student Sonia Hicks explain her class's display. (*Afro-American* Newspapers Archives and Research Center.)

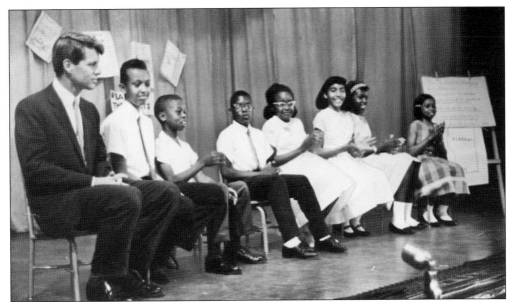

On June 6, 1963, Atty. Gen. Robert Kennedy added Cardozo High and Park View Elementary to the list of schools he had visited, delivering the message that children needed to stay in school and that their hope for future jobs was through education. While at Park View Elementary, Kennedy was seated at the end of a row of child-sized chairs, from which he led an audience participation quiz on history. (Courtesy D.C. Public Library, Star Collection, © *Washington Post*.)

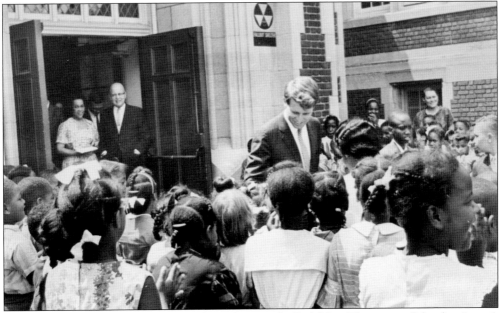

Here Atty. Gen. Robert F. Kennedy is shown leaving the Park View Elementary School on June 6, 1963, after speaking at an assembly there. While Kennedy visited Cardozo High School and Park View, the director of the U.S. Information Agency, Edward R. Murrow, spoke at an assembly at Brown Junior High. The Washington Urban League sponsored the visits in an attempt to unite home, school, and community efforts aiding city youth. (Courtesy D.C. Public Library, Star Collection, © *Washington Post*.)

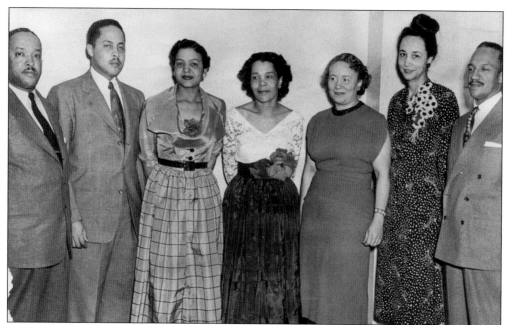

The Park View Parent-Teacher Association was an active partner in the school's educational mission. This undated photograph shows members of the Park View PTA Steering Committee. Those pictured are, from left to right, William Tinney, Mayland McClellan, Mrs. John Murry, Mrs. Wesley Williams, Mrs. Maurice Weeks, Mrs. George Whitted, and Wesley Williams. (*Afro-American* Newspapers Archives and Research Center.)

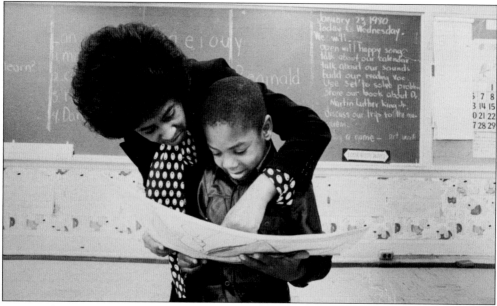

Joan B. Sherrill, photographed here with first-grade student Robert Gayles in 1980, was among the teachers making a difference at Park View. Sherrill would teach her students as one group for approximately half of the day, teaching them to add and subtract or focusing them on group activities. The other half of the day the students were split into two groups based on their reading ability. (Courtesy D.C. Public Library, Star Collection, © *Washington Post*.)

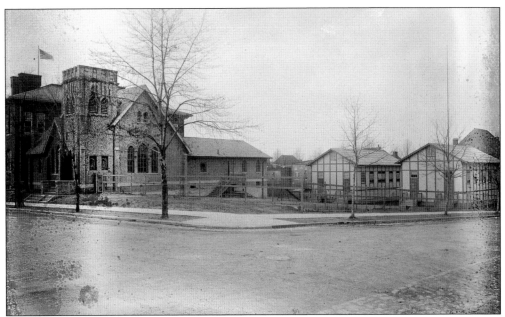

School overcrowding was a problem in many "suburbs" by the 1920s. Two percent of Park View's children attended the Petworth School on Shepherd Street when this photograph was taken in 1920. Whereas the Park View School turned to the two-platoon system and three portable classrooms, the Petworth School required five portable classrooms in addition to holding classes in a former two-story residence and in two rented rooms in the United Presbyterian Church. (Library of Congress.)

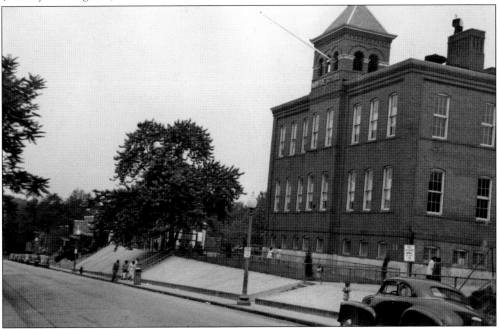

The Monroe School, built around 1899, was integral in educating the children of Park View. Twenty-one percent of the neighborhood's children were attending this school in 1920. (Historical Society of Washington, D.C.)

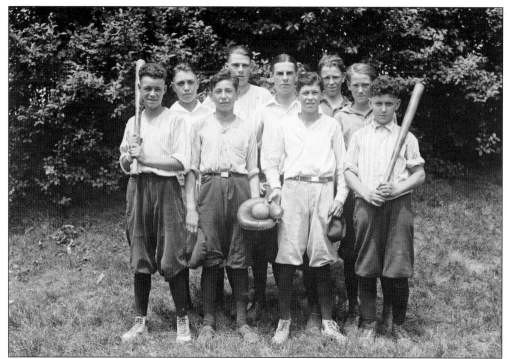

This group of softball players, photographed on June 23, 1923, was composed of Monroe students. (Library of Congress.)

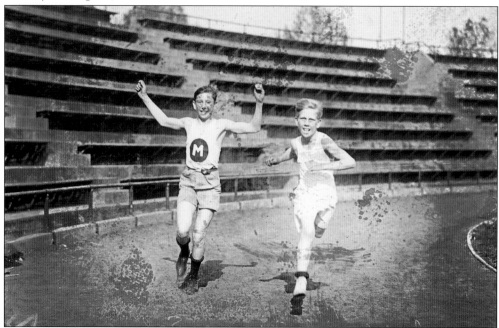

Athletic events within and between schools offered additional opportunities for healthy competition between youth. In this photograph from 1923, Isadore Udelavich from the Monroe School competes in a footrace against Roger Leverton from Park View on the grounds of Central High School. (Library of Congress.)

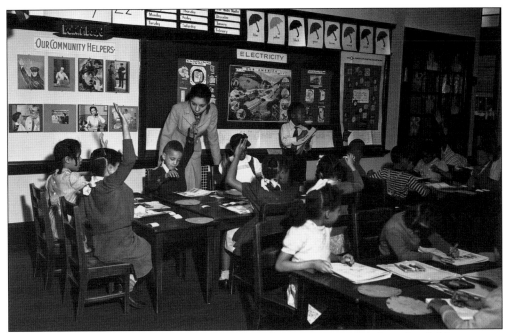

To better serve the growing African American community around the school, Monroe was transferred to the "colored division" in 1931. This image captures the classroom of Mrs. Winters during the 1940s. (Photograph by Addison N. Scurlock. Scurlock Studio Records, *c.* 1905–1994, Archives Center, National Museum of American History.)

This image, dating to the 1940s, documents Monroe School students of Mrs. Pearson in costume for a school play. (Photograph by Addison N. Scurlock. Scurlock Studio Records, *c.* 1905–1994, Archives Center, National Museum of American History.)

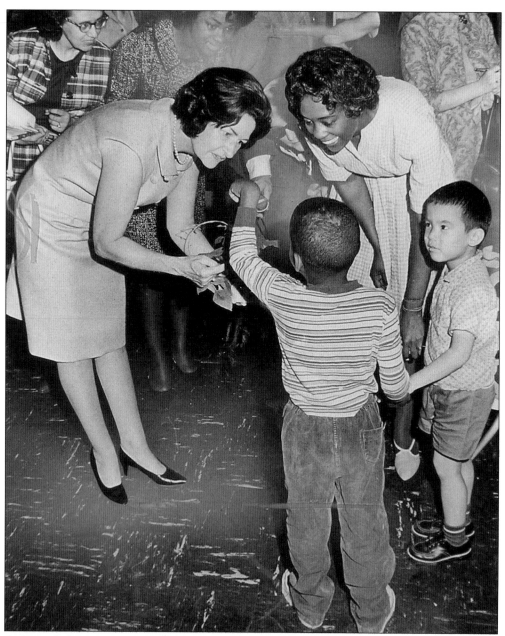

On May 5, 1965, Lady Bird Johnson visited the Trinity A.M.E. Zion Church (see page 32) to observe a poverty program preschool. The Trinity School was one of five pilot projects established by United Planning Organization (UPO) in October 1964. Though not affiliated with the Head Start Centers, which was planned for that summer, the objectives of the two programs were very similar—to expose preschool children from low-income families to otherwise unavailable cultural stimulus to help prepare the youngsters for kindergarten and first grade. During her visit, the first lady watched four- and five-year-olds washing dishes with toy utensils in a big tub of water, making bread with flour-and-water dough, painting pictures, and proudly showing off the chickens and bean plants that they were raising. Reportedly, Mrs. Johnson was impressed by her visit. (Courtesy D.C. Public Library, Star Collection, © *Washington Post*.)

Ground was broken for a new school combining the old Bruce and Monroe Schools on October 5, 1971. As part of the ceremony, Lisa Nix, age seven, of the Bruce school, and Jonathan Brooks, age eight, of the Monroe school, were chosen for the ceremonial ground-breaking (seen here). Also on hand was School Board president Anita F. Allen. When the Bruce-Monroe School opened in 1973, Nix and Brooks would again participate in the opening ceremonies. (Courtesy D.C. Public Library, Star Collection, © *Washington Post*.)

The Bruce-Monroe Elementary School, located on Georgia Avenue between Columbia Road and Irving Street, was completed at a cost of nearly $4 million and was open to students in the fall of 1973. It replaced the 74-year-old Monroe School, which was razed, and the 75-year-old Bruce School, which was left standing. (Photograph by Kent Boese.)

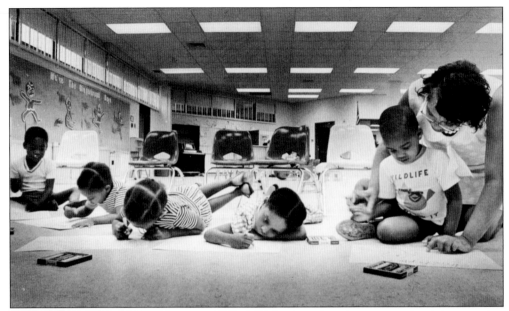

The new Bruce-Monroe School was one of three open-classroom elementary schools in operation when it opened in September 1973. Such schools were built without interior walls. This image, from July 25, 1973, gave a preview of what parents could expect. Here, teacher Naomi Mills helps three-year-old Christopher Proctor with a drawing, while his fellow preschoolers shun chairs for the floor. (Courtesy D.C. Public Library, Star Collection, © *Washington Post*.)

The Bruce-Monroe Elementary School proved to be short lived. Though first opened to the public in 1973, its open-classroom plan proved a challenge to educators. Over the years, the school also experience problems including rodents, heating, and criminal activity on the property. Demolition of the building commenced on August 8, 2009. By August 2010, the property had been developed into a public park for an interim use until a long-term use of the land could be determined. (Photograph by Kent Boese.)

Four

COMMUNITY
NEIGHBORHOOD LIFE, PARADES, AND FESTIVALS

From its beginning, Park View has been a neighborhood with a strong ethic of civic involvement and sense of community. In 1908, the year of its organization under the name of Park View, both the Park View Citizens' Association and an amateur baseball team were born. Though the baseball team had a shorter run than the civic association, it made a name for itself in its six years of existence.

Over the years, Park View's many parades and other celebrations demonstrated and reinforced the sense of community. In the past, parades may have celebrated the Christmas season or road improvements along Georgia Avenue. Today the community helps host the annual parade associated with the Caribbean Festival.

Simpler times witnessed baby and beauty contests or plays at the Park View and Monroe Schools. Evening concerts, provided by the drum and bugle corps of Boy Scout Troop 49, were also welcome diversions.

Outside of community organizations, individual citizens—both within and from outside the community—have left their mark both locally and nationally. While the demographics of the neighborhood continue to change, many of the community's concerns have not. Newspaper accounts and meeting minutes from different eras are similar in their focus on education, recreation, crime, and civic engagement.

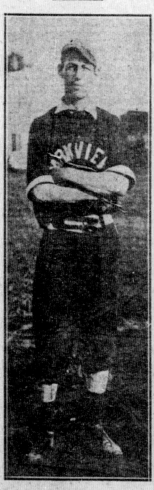

McFARLAND,
Pitcher of the Parkview team of the Suburban
League.

A popular pastime in early Washington was baseball. Numerous amateur leagues sprang up across the area—such as the Sunday School League, the Railroad League, and the Suburban League. The District Suburban League organized some time in mid-1908 with only four teams, one being Park View. Charles McFarland, seen here in 1909, was one of Park View's celebrated pitchers. In singing his praise, the June 11, 1909, *Washington Herald* stated that "McFarland is twirling good ball for Parkview, and he is putting his team in the race, and will probably keep it there if he continues to do as good work as in the past." (*Washington Herald*, Library of Congress.)

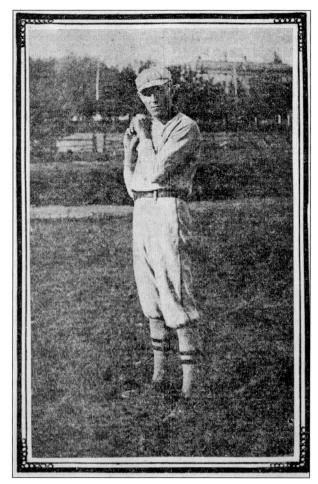

One on the major strengths of the Park View team was pitcher Bernie Gallagher, seen here. Gallagher was a powerhouse who would play for several different teams over the years, but on August 17, 1909, during the race to the championship, his performance before one of the largest crowds of the series placed Park View at the lead of the Class B section by decisively defeating the American Security and Trust Company team. (Courtesy D.C. Public Library, Star Collection, © *Washington Post*.)

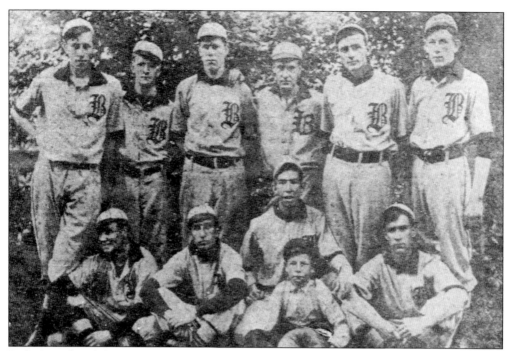

Park View played the Brightwood team, pictured here, in the 1909 season opener. Later that year, the two teams competed for the league pennant. Park View prevailed and won the pennant in a game that reportedly drew a crowd of 1,200. (*Washington Herald*, Library of Congress.)

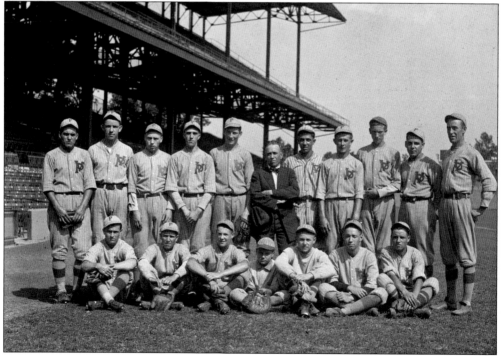

The Park View Juniors were considered to be a strong ball team when this photograph was taken at Griffith Stadium in 1922. (Library of Congress.)

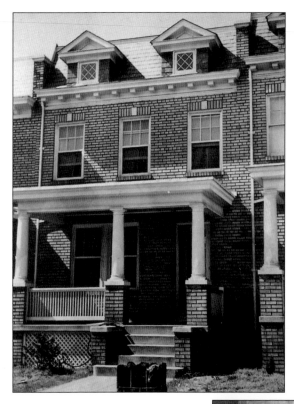

In the 1930s, sandlot baseball (similar to today's little league) was a popular summer pastime. The headquarters of the Columbian Athletic League, consisting of 23 sandlot teams in 1936, was the home (seen at left) of 18-year-old Joseph Cohen. Cohen was president, publicity director, manager, treasurer, and errand boy for the Columbian League, which was made up of almost 300 boys in 1936. Teams were divided into the Peewee (boys under 15), Insect (boys under 16), and Midget (age limit 18) circuits. (Courtesy of the Washingtoniana Division, D.C. Public Library.)

Joseph Cohen's impetus to become involved arose from an event in 1932 when he was 14. While playing on a Peewee team that won the championship, the gentleman running the league failed to deliver the promised trophies to the victors. During a 1936 interview, Cohen said of the event, "I saw my duty and I did it. I organized the Columbian League—and we've always given the rewards promised." (The *Washington Post*.)

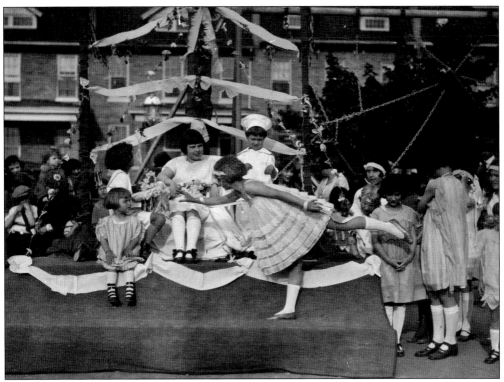

Parades and celebrations involving children, such as this one dating to the early 1930s, were frequent occurrences near the school and playground. The Park View playground and playhouse were dedicated on November 15, 1932, with singing, speech making, and the planting of a Chinese elm tree. (Historical Society of Washington, D.C.)

BABY CONTEST
sponsored by
THE WILLING WORKERS CLUB
TRINITY A. M. E. ZION CHURCH
627 Park Road, N. W., Washington, D. C.

November 8, 1968 – 8:00 p.m.

Winner receives a Savings Bond! Each Baby
receives one-fourth of money raised!

Audrey White J. H. Satterwhite
President Vote....10¢ Pastor

The occasional baby contest was a popular community event. This 10¢ voucher from 1968 allowed the bearer to vote in the contest held at the Trinity A.M.E. Zion Church on Park Road. The winning baby received a savings bond. (Kim Roberts.)

Park View's Boy Scout Troop 49 was particularly well known for its drum and bugle corps, pictured here in 1927, under the direction of Scoutmaster John S. Cole and Sgt. Henry Loveless. The corps was organized in 1917 and frequently performed at neighborhood celebrations as well as more public events—including Flag Day parades and wreath-laying ceremonies at Arlington Cemetery's Tomb of the Unknown Soldier and George Washington's grave at Mount Vernon. (The *Washington Post.*)

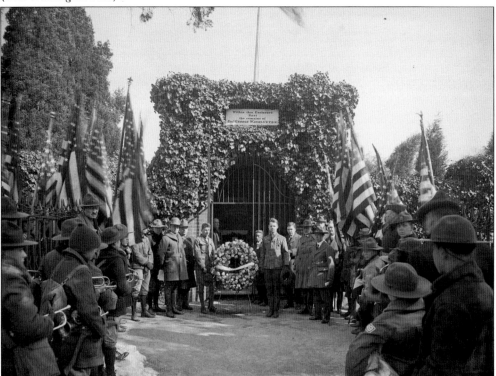

Troop 49 consistently participated in the Boy Scouts' annual pilgrimage to the grave of George Washington to honor Washington's birth. This photograph of the Park View troop dates to the early 1920s. According to a 1926 account in the *Washington Post*, Troop 49's drum and bugle corps played "field music" during the ceremony. (Library of Congress.)

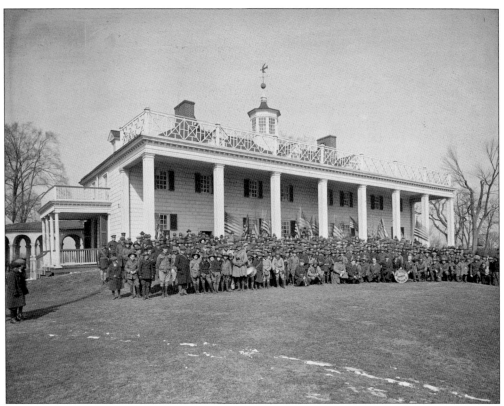

This photograph is from the February 23, 1925, annual Boy Scout pilgrimage to Mount Vernon. It shows all the participants, including the Park View troop. (Library of Congress.)

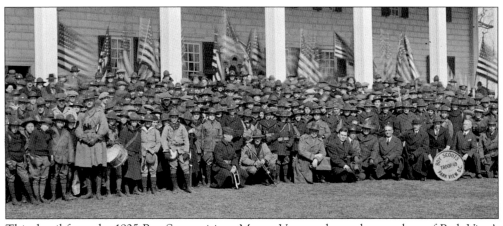

This detail from the 1925 Boy Scout visit to Mount Vernon shows the members of Park View's Troop 49 placed prominently front and center. Their instruments easily identify them. (Library of Congress.)

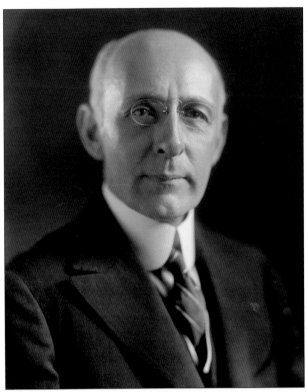

Upon the completion of the Park View School in 1916 (see page 42), the community organized five days of celebrations to honor the new school and the completion of Georgia Avenue's paving. The events were kicked off with a band-escorted automobile parade. The city's mounted police also participated in the parade. At the opening exercises, Justice Frederic L. Siddons of the District Supreme Court, seen here, was one of several distinguished speakers who praised Park View's community spirit. (Library of Congress.)

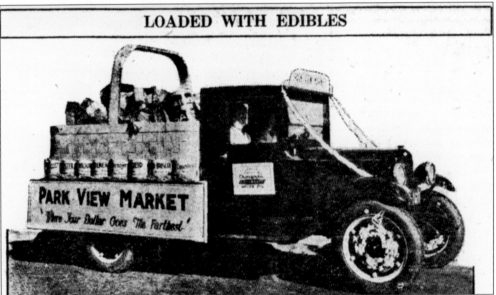

On October 13–14, 1927, more than 20,000 people gathered to celebrate the removal of central streetcar poles from Georgia Avenue and the installation of high-power streetlights. On the first day of celebration, cheering celebrants lined Georgia Avenue and watched a parade of more than 200 decorated automobiles and floats, while blowing tin horns and showering their neighbors with confetti. The Chevrolet truck pictured here was the prize-winning float of the Park View Market, located at 3509 Georgia Avenue. (The *Washington Post*.)

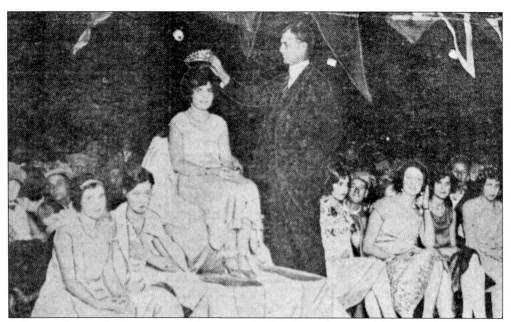

Following the parade, there was a celebration at the Park View playground. Engineer Commissioner William B. Ladue was among the 2,000 people who attended this celebration. Ladue had the honor of crowning 19-year-old Catherine Beck as queen of the carnival. Beck lived at 512 Newton Place and is pictured here with the festival's maids of honor during the crowning. (Courtesy D.C. Public Library, Star Collection, © *Washington Post*.)

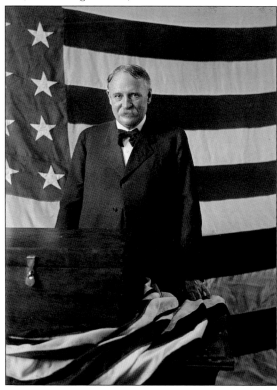

John G. McGrath was frequently referred to fondly as the "Mayor of Park View," though no such office existed. It was in his house that the Park View Citizens' Association was founded with McGrath as president. McGrath's other accomplishments included being elected community secretary in 1917 and having cofounded the Federation of Citizens' Associations. His most lasting contribution is having been chiefly responsible for winning the 12-hour shift for D.C. firefighters and abolishing the 24-hour shift. While an early civic pioneer in Washington, he was employed by the Treasury Department. In 1927, McGrath retired from Washington and moved to a quiet farm in Lewistown, Maryland. (Library of Congress.)

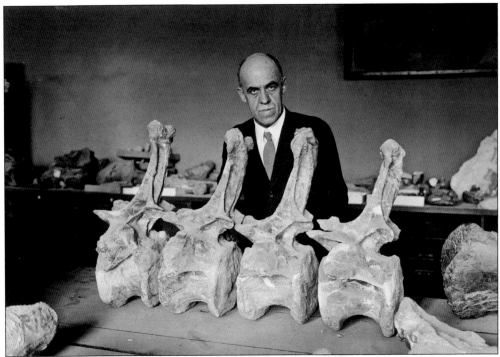

Park View resident Charles W. Gilmore (1874–1945) became curator of vertebrate paleontology at the U.S. National Museum in 1903, where he worked until his death. He is pictured here in 1924 with fossils from a diplodochus. He was in charge of mounting the world's first triceratops skeleton for exhibition at the Smithsonian Institution. In 1920, Gilmore gave the Park View School a plaster model of the Smithsonian's triceratops skull. (Library of Congress.)

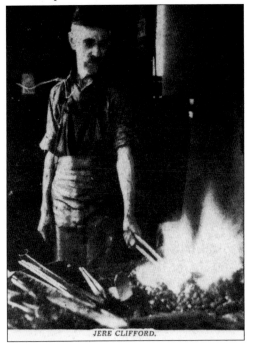

JERE CLIFFORD.

Jeremiah Clifford was among the last blacksmiths in Washington. His shop was located at 813 Otis Place, where he shod the horses of the mounted policemen and tended to fire horses and cavalry horses. By his reckoning, he shod over 100,000 horses and mules in his lengthy career, which started in 1884 when he was 17. (The *Washington Post*.)

Grace Darling Seibold (c. 1869–1947) lived at 756 Rock Creek Church Road until her death. When her son, George, went missing in World War I, she began visiting area hospitals hoping George had been wounded and returned home. Through this experience, Seibold organized and served as the first president of a group that became the Gold Star Mothers. Serving mothers whose sons lost their lives in military service, the organization was named after the star that families hung in their windows to honor the deceased. (American Gold Star Mothers.)

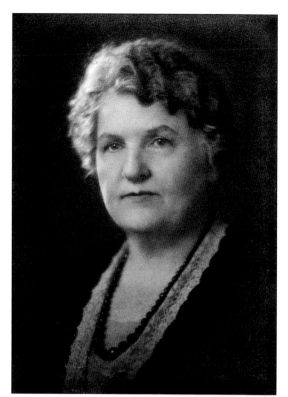

The District of Columbia chapter of National American War Mothers gathered on October 12, 1924, to dedicate a tree at the Lincoln Memorial in honor of the mothers of District men and women who served in World War I. As fate would have it, Grace Goodhue Coolidge suddenly appeared alighting with a Secret Service man from a White House automobile. Grace Darling Seibold (left), president of the chapter, overtook Coolidge (center) in her walk and escorted her to the stand that had been erected for the exercises. (Library of Congress.)

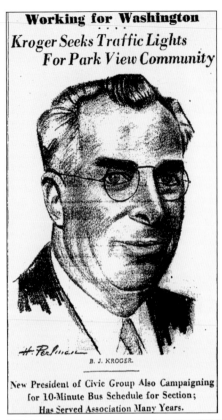

Working for Washington

Kroger Seeks Traffic Lights For Park View Community

H. Perlman

B. J. KROGER.

New President of Civic Group Also Campaigning
for 10-Minute Bus Schedule for Section;
Has Served Association Many Years.

Benjamin Joseph Kroger (c. 1880–1958) lived for many years at 620 Kenyon Street. In 1938, he was elected president of the Park View Citizens' Association, and he held that post for more than four years. His chief focus as head of the association was traffic safety and better bus service. (The *Washington Post*.)

Eugene Allen (1919–2010) and his wife, Helene, moved onto the 700 block of Otis Place in 1946. Allen started at the White House as a pantry man in 1952 and worked his way up to maitre d' in 1980 before retiring in 1986. Allen served through the presidencies of Harry S. Truman to Ronald Reagan. Allen and President Ford shared the same birthday, July 14. This photograph captures Ford's birthday celebration in 1975, at which his wife, Betty, had announced that it was Allen's birthday too. (Allen family.)

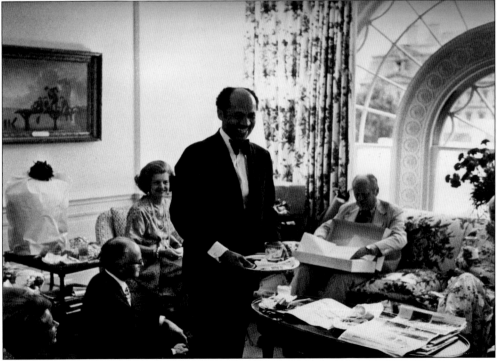

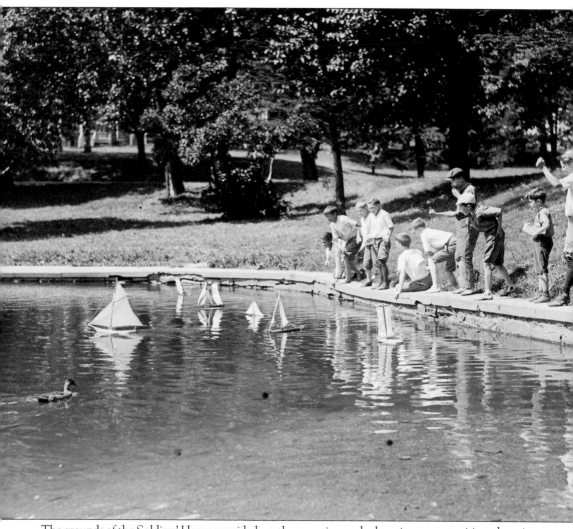

The grounds of the Soldiers' Home provided youth recreation and relaxation opportunities otherwise not available during Park View's early years. Whether sailing boats on the duck pond, as shown here in the early 1920s, or sledding in the winter, children enjoyed the grounds throughout the year. (Library of Congress.)

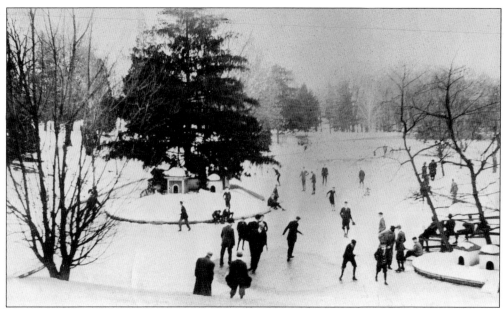

The duck pond at the Soldiers' Home provided recreation in the winter as well as the summer. This undated photograph shows a busy skating season on the grounds. (Historical Society of Washington, D.C.)

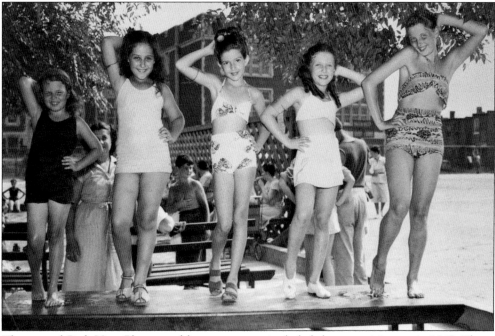

The annual Park View Playground beauty contest included these participants in 1947. Those pictured are, from left to right, Dorothy Kerr, age 8; Jackie Postal, age 8; Sandra Freedman, age 9; Charlotte Postal, age 10; and Catherine Clark, age 12. (Courtesy D.C. Public Library, Star Collection, © *Washington Post*.)

Santa Claus waved a greeting as the Park View Businessmen's Association opened "Yuletide Lane," a parade on Georgia Avenue between Irving and Quincy Streets on the evening of December 2, 1937. (The *Washington Post*.)

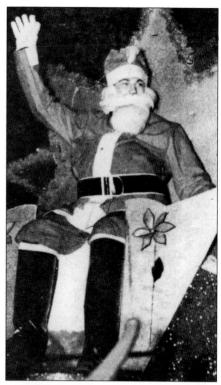

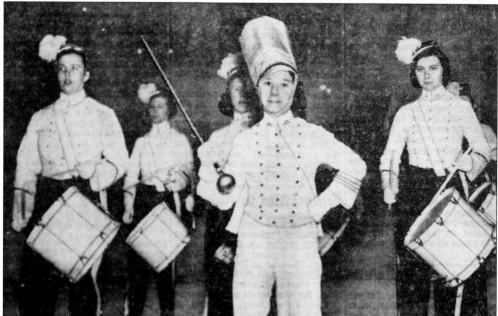

Anacostia's Jobs Daughters, pictured here, were judged the best marching unit in the 1938 Georgia Avenue Yule Lane parade. The event continued to be sponsored by the Park View Businessmen's Association and attracted more than 10,000 viewers. The parade included Santa Claus, half a dozen bands, Washington Boy Scouts, and military and patriotic organizations. (Courtesy D.C. Public Library, Star Collection, © *Washington Post*.)

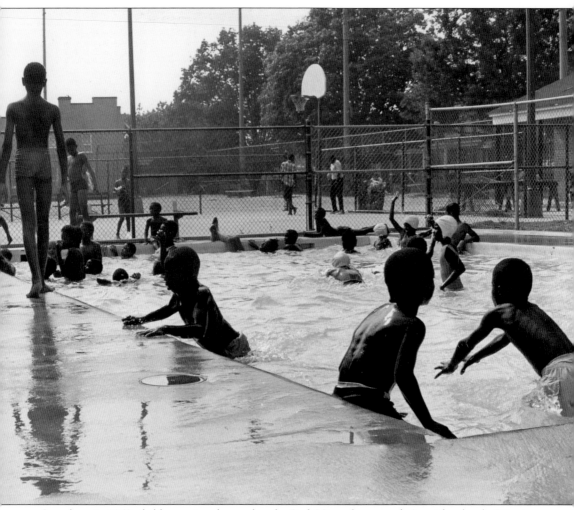

Seen here in 1969, children enjoy the pool at the Park View playground. As with schools, District playgrounds were once segregated. The Park View playground was officially approved for integration on May 7, 1952, making it one of the first seven playgrounds open to both black and white children. That left 128 segregated play areas in Washington. (The *Washington Post*, Getty Images.)

In 1980, seen outside of the Trinity A.M.E. Zion Church at 625 Park Road (see page 32), is the wedding party of newly married Samuel and Yvette Whittaker (right). Samuel's parents, Earthel and Stephanie Whittaker, moved to Park View in the early 1960s, purchasing a house on Rock Creek Church Road where they still reside. Among the guests at the wedding were Randie Moppin (below, second from left). (Both, Randie Moppin Thorpe.)

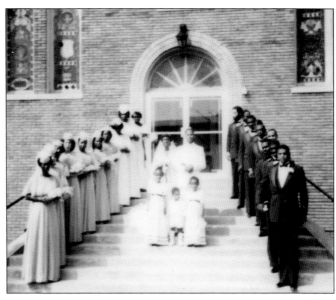

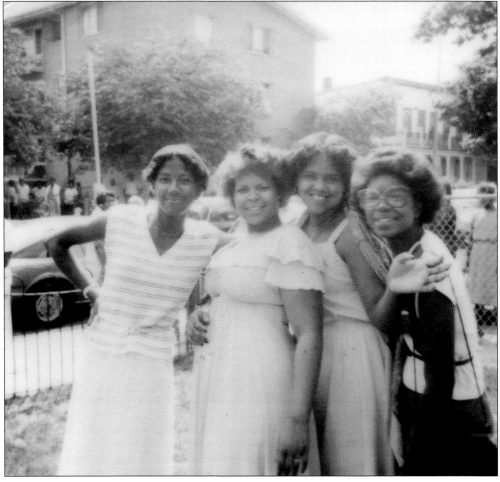

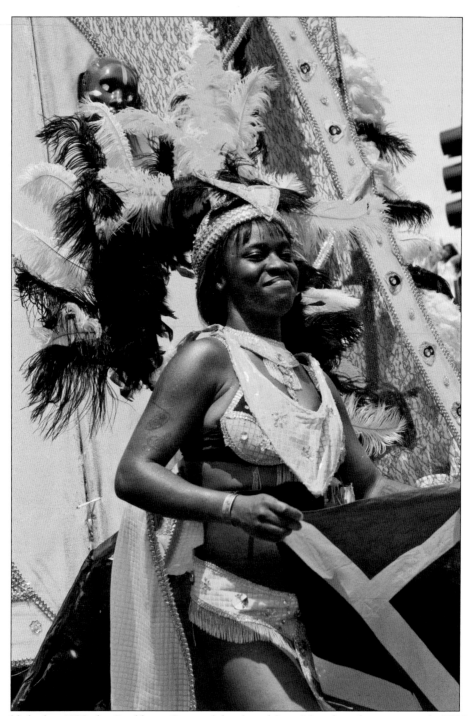

Established in 1993, the Caribbean Carnival developed from 9 bands and approximately 150,000 spectators the first year to 25 bands and well over 300,000 spectators in 2009, according to estimates by the Washington Metropolitan Police. Participating groups include representatives from every Caribbean country. The carnival has enjoyed support from several local, national, and family-owned businesses. (Photograph by Lauri Hafvenstein.)

Five

GEORGIA AVENUE
COMMERCIAL HEART
OF THE COMMUNITY

Georgia Avenue is the lifeline of Park View. Dating to 1810, the Seventh Street Turnpike began at Boundary Street (Florida Avenue), the northern border of the city of Washington, and continued to Rockville, Maryland. Though the County of Washington was abolished in 1871, which united the entire District of Columbia as one city, Georgia Avenue largely remained a rural thoroughfare until the housing boom of the early 20th century.

The neighborhood's location along the avenue, which was a streetcar route, hastened development. With few exceptions, the major part of the community was built between 1906 and 1925. New residents meant new businesses moved in to capitalize on the opportunity.

Georgia Avenue quickly developed, and grocery stores, shoe shops, haberdashers, and other businesses sprang up. As personal automobile ownership rose, so did gas stations and automobile supply shops. The avenue also witnessed the development of the modern supermarket, as the multi-vendor Park View Market was redeveloped into the first Giant supermarket.

The riots of 1968 began a new chapter for the avenue, one of decline and hard times. While the riots were far less severe on Georgia Avenue than they were on U Street, H Street, or Fourteenth Street, the avenue experienced its share of looting. The York Haberdasher and Peoples Drugstore were among the few businesses that were burned in the riots. While some would remain and rebuild, Peoples Drugstore and Woolworths would follow the lead of many merchants who chose to relocate. Ultimately, it was drug culture that most impacted the neighborhood and Georgia Avenue in the 1980s and 1990s.

The opening of the Columbia Heights and Georgia Avenue–Petworth Metro stations in 1999 signaled a sea change, once again. Their opening better connected the area with the city and began a process of renewal. As of 2010, Georgia Avenue was among the last great corridors to receive significant attention, but that situation was changing. Community involvement and developer interest continue to show promise for a rejuvenating and vibrant corridor, indicating that the story of Georgia Avenue is far from over.

Georgia Avenue was originally known as the Seventh Street Turnpike and was built in 1810. It connected Washington, D.C., with Rockville, Maryland, and left the city from its northern boundary where Seventh Street crosses today's Florida Avenue. It later became known as Brightwood Avenue after the development of suburban communities, notably Brightwood, began to appear outside of Washington proper. This image captures Georgia Avenue in the 1890s. (Historical Society of Washington, D.C.)

In 1894, Augustus Octavius Bacon (1839–1914) came to Washington to represent Georgia in the U.S. Senate. The Georgia Avenue he found here—then located in Southeast—did not please him. It was unpaved, full of potholes, and frequently a muddy mess. Rather than use his position to hasten repair of Georgia Avenue, Bacon instead pushed an amendment through Congress in 1908 to have Brightwood Avenue renamed Georgia Avenue. The original Georgia Avenue was renamed Potomac Avenue, SE. (Library of Congress.)

In the first half of the 20th century, the District had a robust streetcar network, with more than 200 miles of track and multiple companies providing service. Georgia Avenue was among the older routes and initially relied on horse-drawn cars. In 1909, the city phased in new pay-as-you-enter streetcars. The chief advantage of the new cars was a dedicated entrance, eliminating the confusion of passengers running in to each other as they entered and exited the cars. This advertisement alerted residents living along Georgia Avenue of when the new cars would be on their line. (*Washington Times*, Library of Congress.)

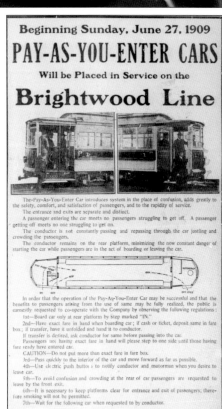

Beginning Sunday, June 27, 1909

PAY-AS-YOU-ENTER CARS

Will be Placed in Service on the

Brightwood Line

The-Pay-As-You-Enter Car introduces system in the place of confusion, adds greatly to the safety, comfort, and satisfaction of passengers, and to the rapidity of service.

The entrance and exits are separate and distinct.

A passenger entering the car meets no passengers struggling to get off. A passenger getting off meets no one struggling to get on.

The conductor is not constantly passing and repassing through the car jostling and crowding the passengers.

The conductor remains on the rear platform, minimizing the now constant danger of starting the car while passengers are in the act of boarding or leaving the car.

In order that the operation of the Pay-As-You-Enter may be successful and that the benefits to passengers arising from the use of same may be fully realized, the public is earnestly requested to co-operate with the Company by observing the following regulations:

1st—Board car only at rear platform by step marked "IN."

2nd—Have exact fare in hand when boarding car; if cash or ticket, deposit same in fare box; if transfer, have it unfolded and hand it to conductor.

If transfer is desired, ask conductor for same before passing into the car.

Passengers not having exact fare in hand will please step to one side until those having fare ready have entered car.

CAUTION—Do not put more than exact fare in fare box.

3rd—Pass quickly to the interior of the car and move forward as far as possible.

4th—Use electric push button to notify conductor and motorman when you desire to leave car.

5th—To avoid confusion and crowding at the rear of car passengers are requested to leave by the front exit.

6th—It is necessary to keep platforms clear for entrance and exit of passengers; therefore smoking will not be permitted.

7th—Wait for the following car when requested to by conductor.

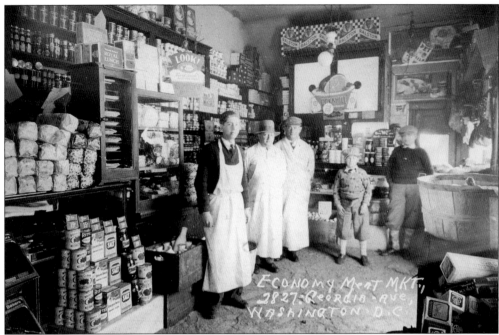

The property at 2827 Georgia Avenue has a long history of serving the surrounding community as a market. This photograph from 1928 shows, from left to right, Louis Shankman, Joseph Shankman, Morris Folstein (meat supplier), Bernie Shankman, and Nathan Shankman inside the Economy Meat Market. Joseph Shankman operated this market from 1927 through 1932. Between 1914 and 1934, a total of 10 different grocers were associated with this location. (Jewish Historical Society of Greater Washington.)

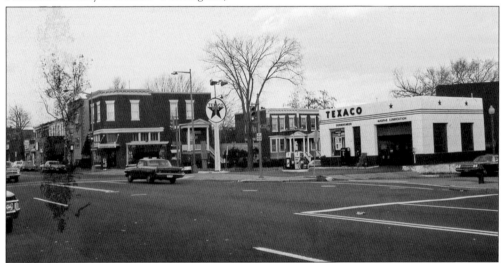

Construction of this Texaco service station at 2921 Georgia Avenue was begun in 1929. The one-story building was a brick and tile structure. The gas station was damaged on June 11, 1938, when a 1,000-gallon tank truck was transferring gasoline to a storage tank and it ignited. The station manager, P. E. Hicks, and the truck driver quickly capped several open storage tanks, which prevented an explosion. This image shows how the Texaco looked in December 1967. (Historical Society of Washington, D.C.)

Georgia Avenue between Columbia Road and Irving Street was once lined with row houses. This photograph shows the west side of Georgia Avenue and dates to October 10, 1949. They were eventually razed to make way for the Bruce-Monroe School, which broke ground in 1971. (Historical Society of Washington, D.C.)

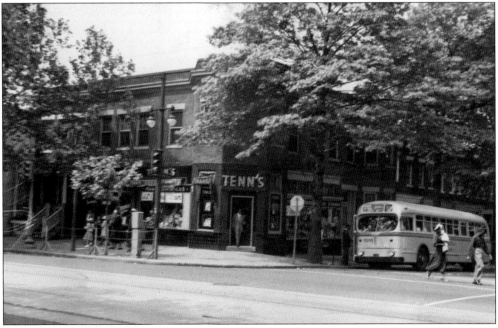

Tenn's haberdasher, on the southwest corner of Georgia Avenue and Irving Street, sold clothing and jewelry. Proprietor William Tenn fell victim to robbers in May 1943, when they entered the building by removing a wooden panel from the rear door of 3038 Georgia Avenue. A total of $535 in cash, over $100 in checks, and an unknown amount of jewelry was taken from an unlocked safe. (Historical Society of Washington, D.C.)

The Carron Baptist Church congregation built this structure at 3102 Georgia Avenue around 1948 and held services there through 1966. Today the church is located at 1354 First Street, SW. (Historical Society of Washington, D.C.)

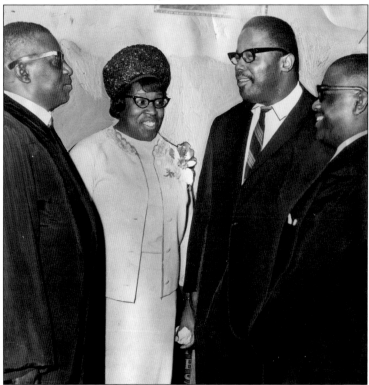

During the occasion of Carron Baptist's 41st anniversary, many of its church leaders were photographed. Those pictured are, from left to right, Rev. and Mrs. Leroy Waldo; the chairman of the deacon board, Bernard Wilson; and the assistant chairman of the deacon board, Melvin Smith. (*Afro-American* Newspapers Archives and Research Center.)

Pictured at right are other church members in attendance of the 41st anniversary. They are, from left to right, Ruth Battle, Mrs. Elmer Stephens, Janice Fox, and Virginia Ware. Those pictured below are, from left to right, Thomas Blair, assistant pastor and superintendent of the Sunday school; Deacon Randall Lawson; Deacon Georgia F. Brown; and Dorothy Jackson, financial secretary. (Both, *Afro-American* Newspapers Archives and Research Center.)

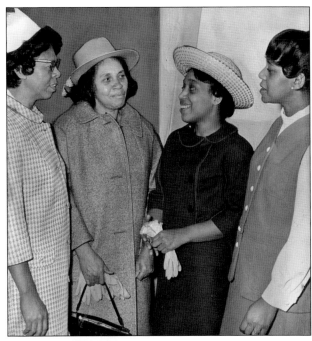

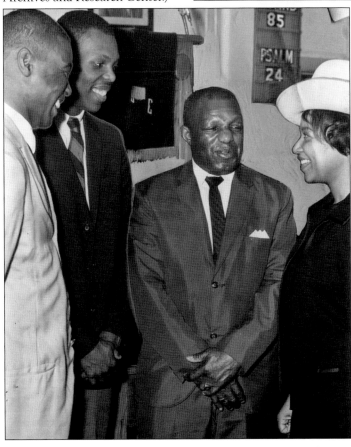

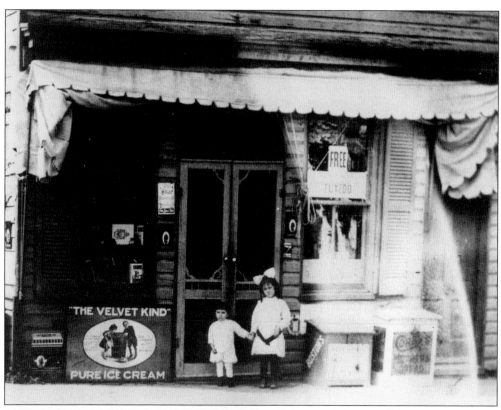

Robert and Augusta Silverman were photographed in front of their father's store at 3200 Georgia Avenue in 1914. Morris Silverman's grocery on the northwest corner of Georgia Avenue and Kenyon Street opened in 1912 and operated until 1917. As with the Economy Meat Market (see page 80), the store would see a succession of owners. The most stable purveyor was Abraham Leonard, who operated a grocery here from 1926 through 1930. (Jewish Historical Society of Greater Washington.)

Morris N. Morgan (c. 1922–1983) came to Washington as a child to live with an older sister. He went to public school and attended Howard University. In the 1940s, when Washington neighborhoods were still segregated, he opened a poolroom on the 3200 block of Georgia Avenue. (*Afro-American* Newspapers Archives and Research Center)

For many years, 3200 Georgia Avenue was well known for Morgan's Seafood and its owner, Morris N. Morgan. In 1963, Morgan opened the crab house on the northwest corner of Georgia Avenue and Kenyon Street. Politicians recognized Morgan as popular within the community and sought his endorsement, and those in the community brought their problems to him because he knew the politicians. (The *Washington Post*.)

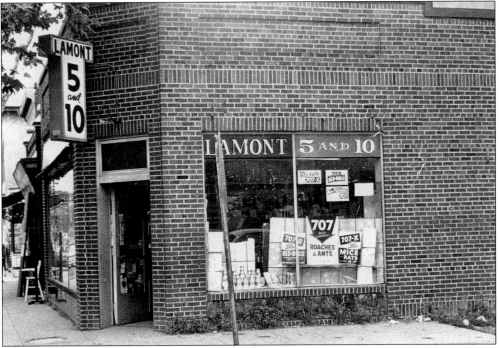

Sam Rosen opened this neighborhood 5¢ and 10¢ store on Georgia Avenue and Lamont Street around 1948. During the riots of April 1968, Sam learned that his business had been looted. While inspecting the store with his brother on April 6, Rosen found what he had expected—smashed display cases and windows, with debris strewn across the floor. (Larry Rosen.)

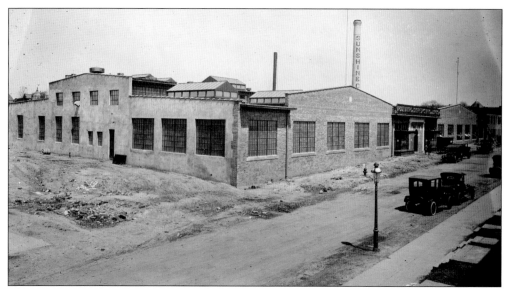

The Arcade-Sunshine Laundry evolved from a one-room tailor and dry-cleaning shop founded by Harry Viner at 3219 Mount Pleasant Street in 1907. Viner was the first businessman in Washington to combine a dry-cleaning plant with a laundry, and his business merged with the Arcade laundry in 1918. Work on the facility at 713 Lamont Street began that year. He was considered a pioneer in dry-cleaning and was codeveloper of the Stoddard solvent, which became the standard in the business. (Library of Congress.)

This section of the laundry focused solely on cleaning shirt collars. Unlike men's shirts of today, shirt collars were once separate garments that attached to shirts with buttons. This allowed for ease of cleaning and the replacement of a collar without the need to replace the entire shirt. (Library of Congress.)

THE "SPOTTING" SECTION
of the dry cleaning department.

Here gentlemen of the spotting section of the Arcade-Sunshine dry-cleaning department are hard at work. (The *Washington Post*.)

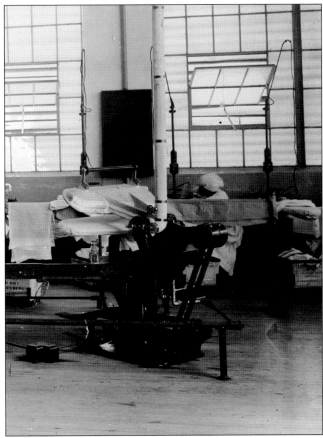

The laundry and dry-cleaning industry was one of the few career opportunities open to women. Here a woman is working in the pressing and finishing section of the Arcade-Sunshine dry-cleaning department around 1920. (Library of Congress.)

As part of the new plant's opening festivities, Arcade-Sunshine invited every Washington housewife to inspect the cleanest, largest, sunniest, and most scientific establishment for laundering, cleaning, and dyeing clothes in the United States. This advertisement appeared in the November 20, 1921, *Washington Post*. (The *Washington Post*.)

When an A&P supermarket came to 3400 Georgia Avenue, it occupied a newly completed, one-story, brick-and-cinderblock building. Customers were able to begin shopping there on October 10, 1941. A&P stores were open until 6:00 p.m. and stayed open later on Fridays and Saturdays. The store also advertised free parking. The A&P was located on this corner until 1951. (Historical Society of Washington, D.C.)

A&P stores were jammed with customers during the first week of July 1946, which was when the chain was able to offer the largest supply of meat that was seen in the city in over six months. Crowds packed A&P stores, including the one at 3400 Georgia Avenue, which promised steady, regular meat supplies as long as Office of Price Administration (OPA) controls remained off. Commenting on the meat supply, Raymond C. Briggs, president of L. S. Briggs, Inc., said, "It looks like everybody will have all they want of the best grades in many years, if the industry remains unhampered by controls . . . Prices will take care of themselves when there is more than enough meat to meet the demand." The OPA had been established in 1941 to control prices and rents after the outbreak of World War II. A&P shoppers were as excited by the opportunity to buy meat at OPA prices or below, as they were by the quantity of meat being offered. (The *Washington Post*, Getty Images.)

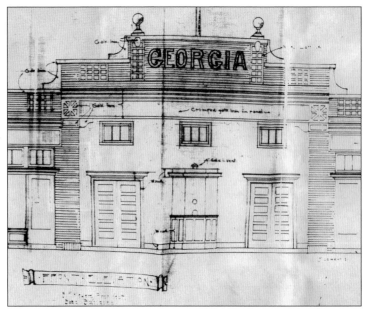

The Georgia Theater was built in 1912. At the time it was dismantled in 2007, it was Washington's oldest surviving theater after the Minnehaha, which today houses Ben's Chili Bowl on U Street. It was designed by B. Frank Myers and was part of a one-story brick strip that contained three stores and the theater. In October 1917, it was renamed Park View. During its final days, the Georgia was an auto repair shop. (Peter Sefton.)

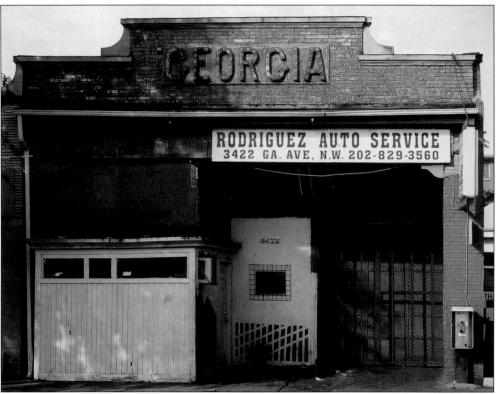

In 2005, the D.C. Preservation League Landmarks Committee was advised that the theater's building had been sold, but that its historic features would be incorporated into a condominium project. At that point, the Georgia had seen better days. A truck had hit it earlier that spring, damaging the corner of the building and causing the developer to opt for demolition rather than incorporating the theater into the project. (Peter Sefton.)

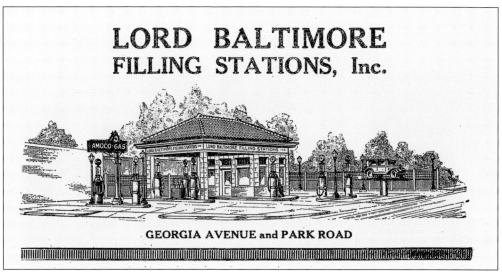

LORD BALTIMORE
FILLING STATIONS, Inc.

GEORGIA AVENUE and PARK ROAD

The southwest corner of Georgia Avenue and Park Road has been associated with providing gas and service to area drivers since 1927, when the Lord Baltimore Filling Station opened on this site. The gas pumps were located so that one was accessible at all times. Additionally, instead of oil pits, new hydraulic lifts were used to raise the car to oil and grease it. (The *Washington Post*.)

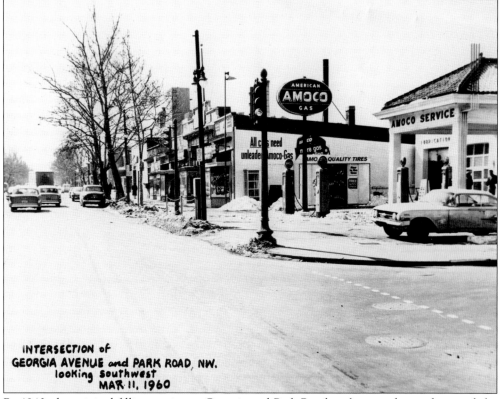

INTERSECTION of
GEORGIA AVENUE and PARK ROAD, NW.
looking southwest
MAR. 11, 1960

By 1940, the original filling station at Georgia and Park Road no longer adequately served the community's needs, and it was expanded by a new $3,000 addition. It is shown as it looked 20 years later on March 11, 1960. (Historical Society of Washington, D.C.)

91

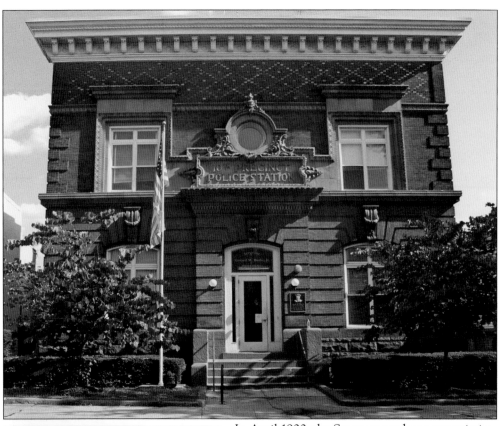

In April 1900, the Senate passed an appropriation bill for $8,000 to provide for a new building and personnel to create the 10th Police District, which encompassed the majority of Northwest Washington. Much of the area was sparsely populated at the time. The architects chosen for the new building were A. B. Mullet and Company, who worked closely with Maj. Richard Sylvester in the design. (Photography by Lauri Hafvenstein.)

Maj. Richard Sylvester (1858–1930) was appointed chief of the Metropolitan Police Force in 1898. Building the new 10th Precinct Building offered Sylvester an opportunity to implement many of his ideas, which were considered entirely new to the police department. Sylvester's two highest priorities for the new station were prisoner security and officers' comfort. (Library of Congress.)

John Kenney became a policeman in the fall of 1883. During President Harrison's term, he was detailed at the White House. On July 1, 1893, he was promoted to mounted sergeant on night duty. When the new 10th Precinct was established and the nearly completed building occupied in the fall of 1901, Lieutenant Kenney was selected to command the precinct and its 49 police officers. (*Washington Times*, Library of Congress.)

LIEUT. JOHN KENNEY,
Tenth Precinct.

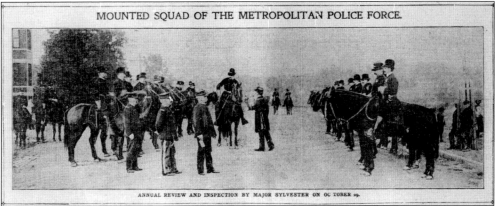

MOUNTED SQUAD OF THE METROPOLITAN POLICE FORCE.

ANNUAL REVIEW AND INSPECTION BY MAJOR SYLVESTER ON OCTOBER 29.

This image from 1903 shows the mounted squad of the Metropolitan Police Force drawn up for inspection by Major Sylvester. The mounted squad was one of the most important branches of the service. They did duty in the 3rd, 5th, 7th, 8th, 9th, and 10th Precincts, being called upon to watch closely all roads entering Washington and to keep a lookout for suspicious characters of all sorts coming into the city or leaving it. (*Washington Times*, Library of Congress.)

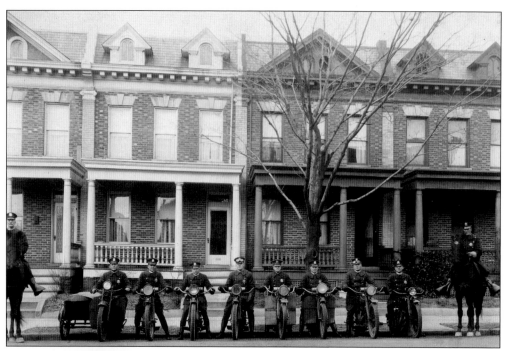

As early as October 1907, Major Sylvester was considering the provision of motorcycles to policemen on duty in the outlying districts. The scheme was the result of the determination of the police to put a stop to violations of the speed regulations by motorists and horsemen. Because of the condition of the roads in the outlying police precincts, it was virtually impossible for a policeman to overtake lawbreakers. This photograph shows the officers of the 10th Precinct on Park Road, across from the station house. (The Metropolitan Police Collection/Lt. Nicholas Breul.)

The 10th Precinct's cells were believed to be the strongest in the city. This provided for an interesting opportunity in 1906, when Harry Houdini was in Washington performing at Chase's Theater. With the agreement of Major Sylvester, Houdini was stripped, handcuffed, and locked in the precinct's cell No. 3 on the morning of January 1, 1906. His clothes were locked in an adjoining cell. Within 20 minutes, Houdini, dressed in his street clothes, was standing among the officers charged with keeping him locked up. (Library of Congress.)

The first of 45 Electric Railway Presidents' Conference Cars (PCC) entered service in Washington on August 28, 1937, serving Fourteenth Street. The Georgia Avenue line received 38 cars in 1939. The following different streetcar lines ran through Park View: the 70, 72, and 74. This undated image shows a PCC car on the 70 line, traveling north on Georgia Avenue. (Historical Society of Washington, D.C.)

The Seventh Street–Georgia Avenue line stretched from the Seventh Street wharves in Southwest to the District border with Maryland at Georgia and Alaska Avenues. This photograph shows a northbound Georgia Avenue PCC car. Like many cities in the United States, the District discontinued streetcar service in favor of buses, with the last day of streetcar operations in Washington being January 28, 1962. (Author's Collection.)

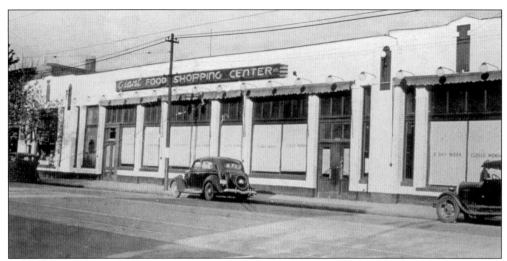

In 1936, Nehemiah Cohen and Samuel Lehrman chose Washington for their new business venture. Choosing the site of the former Park View Market, they opened their first Giant supermarket at 3509 Georgia Avenue in the midst of a snowstorm. At the time of Lehrman's death in 1949, the organization had expanded into 17 branch stores. (Jewish Historical Society of Greater Washington.)

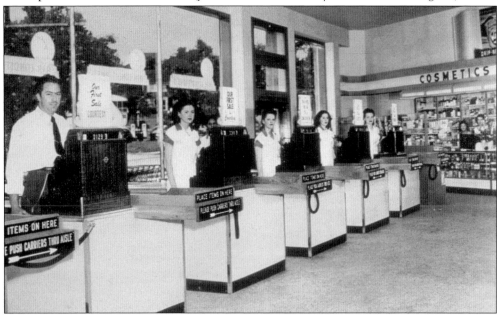

Giant cashiers are shown awaiting their customers. Under Cohen's energetic son, longtime Giant chairman Israel "Izzy" Cohen, Giant became the first chain in the nation to bring in price scanners. He also introduced salad bars and added pharmacies to many Giant stores. Izzy Cohen, like his father, often visited the stores. Because Cohen was always a stickler about produce, store managers knew he would head straight for the bananas to make sure no brown ones were on display. As the chain expanded from one store to about 50 in 1959 and to 157 in early 1994, Cohen tried to keep it running as a family business. In October 1952, the Giant at 3509 Georgia was replaced by a Safeway, which operated there until it closed in the early 1970s. By June 1974, the building had been razed. Today a Laundromat is located on the site. (Jewish Historical Society of Greater Washington.)

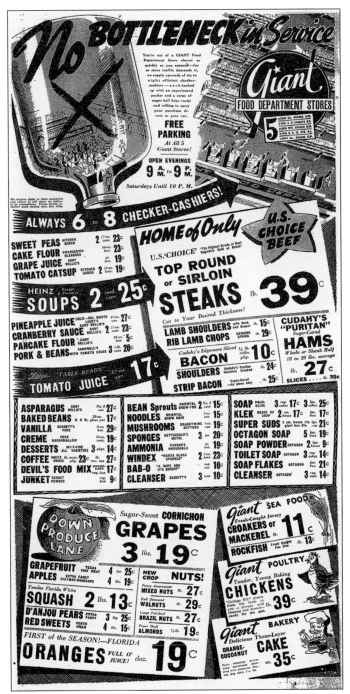

In 1941, Vincent Edwards and Company, publisher of Feed Ad Views, announced that the advertising copy of Giant Food Stores had been selected as the most noteworthy food advertising in the United States for that year. Clarkson Gemmill, advertising manager of Giant, earned the Socrates Award for consistently outstanding layouts and copy arrangements of the advertisements. Giant's advertisements had been among 127 different coast-to-coast grocery concerns in the running. (The *Washington Post*.)

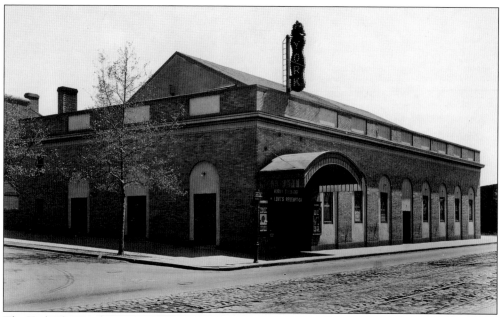

The York Theater, located at 3635–3641 Georgia Avenue, was designed by architect Reginald W. Geare and built by Kennedy Brothers. The York was built as the eighth of Harry M. Crandall's string of Washington, D.C., theaters. The building permit lists the cost of the theater at $50,000, although newspaper accounts claimed $100,000. Construction began on May 22, 1919. By November 26, the theater was open. (Robert K. Headley.)

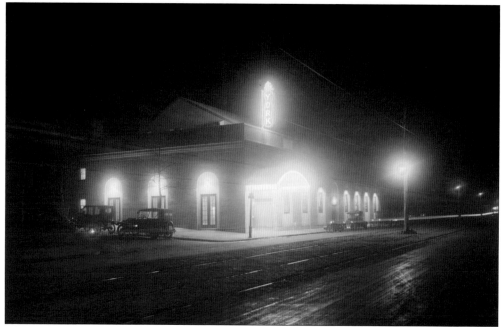

The entrance of the York was surmounted by a marquee of wrought iron, copper, and Tiffany glass, to harmonize with the color treatment of the building, which extended to the curb line. The building was fitted with brilliant floodlights, bathing the entire front of the structure in light. (Library of Congress.)

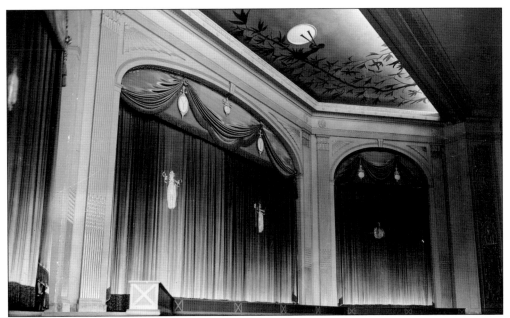

The decorative scheme used throughout the interior of the York was in silver, black, and gold. The proscenium was constructed in three arches, under a silk canopy that extended over the audience and beyond the orchestra platform. The screen and side curtains were of gold silk, further beautified by concealed colored lighting. The gold proscenium hangings were enlivened with blue medallions and white figures in relief. (Robert K. Headley.)

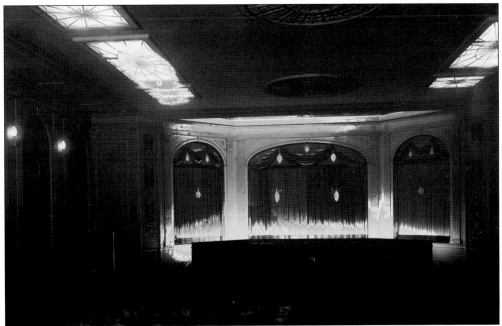

The York had a seating capacity of 1,000, which was all on a single floor. There was no provision for a balcony. For moviegoers' comfort, a new ventilating system unique to the building, and Washington, was installed. This system delivered heated air into the auditorium through the roof in winter and by the same means circulated cooled air in the summer heat. (Library of Congress.)

The display boards in Crandall's theaters, such as this one from the York Theater, were conspicuous among his many innovations, as they were self-lighted. The boards attracted the admiration of thousands of theatergoers. Reginald Wyckliffe Geare designed them in the same style as the lobbies in which they were installed. (Library of Congress.)

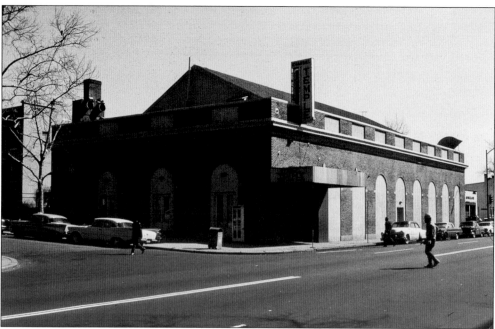

The York survived as a movie theater until May 1954. It was purchased by the National Evangelistic Center in May 1957 and has been used as a church since that time. This photograph dates to March 1965. The building has been home to the Fisherman of Men Church since 1977. (Historical Society of Washington, D.C.)

Harry M. Crandall (1879–1937) got his start as a telegraph messenger boy, earning $12 a month at the age of 12. He also went into the livery business before he pursued the movie business in 1908. It was not long before Crandall built up a chain of theaters throughout Washington. His goal was to have a movie house in each section of the city. He sold his business for $8 million to the Stanley Company of America in August 1925. (The *Washington Post*.)

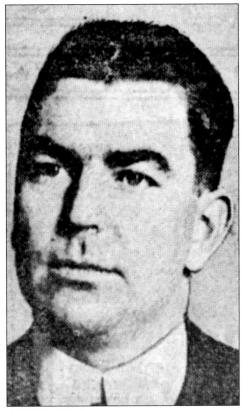

Reginald Wyckliffe Geare (1889–1927) was a well-known architect in Washington, D.C., during the first quarter of the 20th century. His designs included several luxurious movie theaters built for Harry M. Crandall, including the Knickerbocker (1917) and the York (1919). The collapse of the Knickerbocker's roof during a snowstorm on January 28, 1922, killing 98, broke Geare. Though he was cleared of any wrongdoing or negligence in the theater's construction, he was unable to recover from the tragedy professionally. On August 23, 1927, Geare took his own life. (Courtesy D.C. Public Library, Star Collection, © *Washington Post*.)

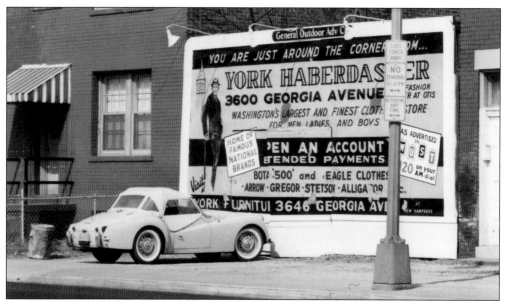

The York Haberdasher at 3600 Georgia Avenue was a fixture in Park View from the time it opened in 1946 to its closing in 1981. Proprietor Carl Lane opened the shop after his service in the army. When he opened his doors, Park View was a mostly white neighborhood. When it became a predominantly African American neighborhood in the 1950s, he adapted and prospered. Unlike other businesses that left the city after the 1968 riots, Lane hung tough and rebuilt his burned-out store. (D.C. Housing Authority.)

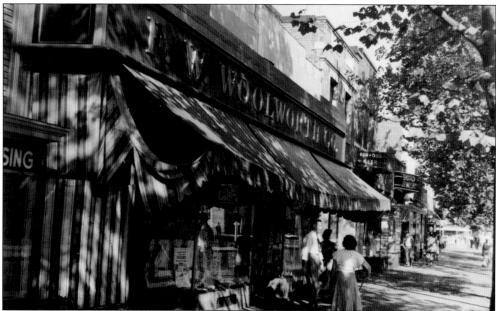

At a zoning hearing on January 4, 1928, the properties at 3614 and 3616 Georgia Avenue were rezoned from residential to commercial uses. F. W. Woolworth Company, pictured here, was firmly established at 3614 Georgia when this photograph was taken on October 10, 1949. It would remain a staple in the community until it was damaged during the 1968 riots. Woolworth's chose to leave the community at that time. (Historical Society of Washington, D.C.)

Dr. Ephraim Edgar Ruebush, a successful veterinary surgeon, opened a new and modern hospital for small animals at 3622 Georgia Avenue in early January 1925. He received local notoriety when he saved a $10,000 show dog in 1935 and successfully treated dogs being poisoned in the Shepherd Park neighborhood in 1936. Ruebush is pictured here in April 1937 after he had removed a record gallstone from Flip, a black and white collie. (The *Washington Post*.)

By 1969, 3622 Georgia Avenue had been replaced by the Pan-African Specialty Shop, operated by Hugh Lofton and his wife. The Reverend Douglas Moore, pictured here, was operating the shop by 1971. He not only created wedding clothes for Americans wishing to be married in African dress but he also performed the ceremonies for them. Moore, a civil rights activist, was a politician who was elected as an at-large councilmember in the District's first election under home rule in 1974. (Courtesy D.C. Public Library, Star Collection, © *Washington Post*.)

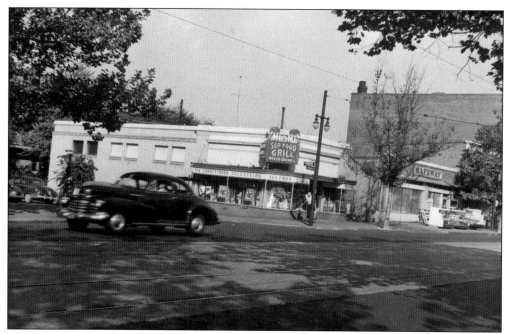

The northwest corner of Georgia Avenue and Princeton Place was photographed on October 10, 1949. It shows the Miami Sea Food Grill at 3642 Georgia Avenue and a Safeway grocery store. The Safeway would eventually relocate to 3509 Georgia Avenue before settling farther north in Petworth during the 1970s. (Historical Society of Washington, D.C.)

As part of the response to a series of murders that began in and around Princeton Place in 1996, Ward 1 councilmember Frank Smith Jr. began weekly meetings at the Park View Elementary School auditorium. The first meetings were heavily attended with a frustrated community lashing out against the police, the city, and landlord John Slack, who discovered bodies in his unoccupied buildings. (© Darrow Montgomery.)

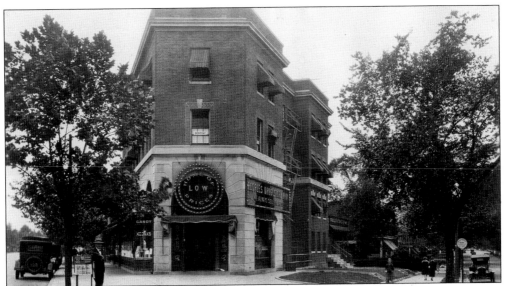

The four-story combination market and apartment building that was once located on the southwest corner of Georgia and New Hampshire Avenues broke ground on July 1, 1922. The entrance to the Shenandoah apartments was on New Hampshire Avenue, with 10 apartments on the second through fourth floors. Peoples Drugstore leased the corner of the building. It was constructed of gray pressed brick and trimmed with white terra-cotta and built at an estimated cost of $200,000. (Historical Society of Washington, D.C.)

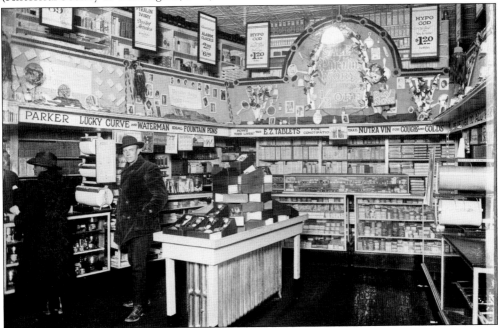

This photograph shows the interior of the Peoples Drugstore at Seventh and K Streets, NW, around 1920, and is typical of drugstore interiors of the time. The drugstore in Park View would have looked similar to this. Peoples Drugstore was another victim of the 1968 riots. Like so many other businesses during the civil unrest, Peoples burned, ending nearly 46 years of serving the neighborhood. (Library of Congress.)

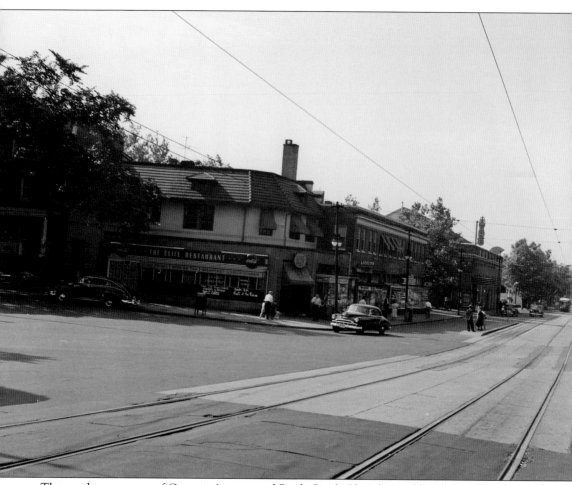

The southeast corner of Georgia Avenue and Rock Creek Church Road has been many things over the years. This photograph shows it as the Elite Restaurant in June 1949. The Elite became the center of a controversial liquor practice in 1953, when the District Alcoholic Beverage Control Board discovered in February of that year that it had been refilling bottles with beverages different from those advertised on the label. Though the Elite case was the first the ABC Board had discovered, further investigation resulted in a report in March that there were "hundreds" of cases in D.C. of bars engaging in this type of fraud. The commissioners decided on March 10, 1953, to give James L. and Eleutherios J. Perrus, owners of the Elite, 30 days to sell their business or have their liquor license revoked. Ultimately, the Perruses sold the business. (Historical Society of Washington, D.C.)

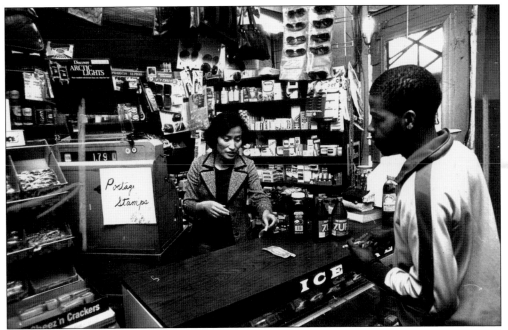

Lee Chun Hee waits on Henry Jones, a neighbor who recalled three previous owners of this corner store at Warder Street and Rock Creek Church Road prior to 1979. By that year, many of the mom-and-pop corner grocery stores that had been ravaged by the 1968 riots were undergoing a rebirth, as Korean immigrants began to own and operate them. (The *Washington Post*, Getty Images.)

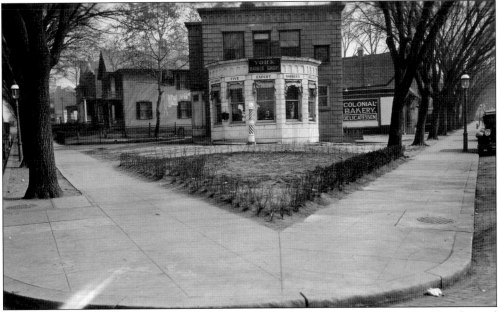

The building on the northeast corner of New Hampshire Avenue and Rock Creek Church Road served as a neighborhood pharmacy in the early 20th century. Henry E. King operated a drugstore here in 1915 and 1916. Collins C. Fenton followed King's ownership from 1917 through 1928. This 1927 photograph shows the York Barbershop operating out of the same building. (Historical Society of Washington, D.C.)

Little Tavern No. 2 opened on February 12, 1929, at 3701 New Hampshire Avenue. The Little Tavern was a hamburger chain founded by Harry F. Duncan in 1927 in Louisville, Kentucky. Its motto was "buy 'em by the bag." Duncan sold the chain in 1981. By 1992, the stand had become a West Indian–American restaurant. (Historical Society of Washington, D.C.)

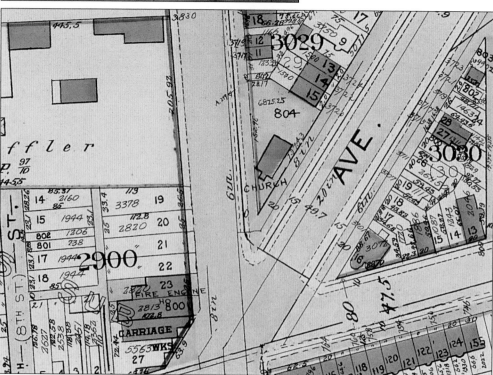

Prior to 1910, the property located on the northeast corner of Georgia and New Hampshire Avenues was vacant. The first structure to be built there was the Petworth Presbyterian Church, which was begun in 1910 and in use by 1911. The use of this corner by the church was short-lived. By August 1919, a new building permit was issued for another use. (Library of Congress.)

The building that replaced the Petworth Presbyterian Church was a single-story brick structure built by Winfield Preston. When the building opened in 1920, it housed True and Company Cleaners and Dyers, at 3703 Georgia Avenue, and the York Auto Supply Company, which was on the corner at 3701. In 1920, an auto-related business was still a relatively new idea. By the time the York Auto Supply Company had broken ground, Washington had one vehicle for every 10.73 residents, ahead of the national average of 14.14 persons per car. (Library of Congress.)

A second story was added to the building at 3703 Georgia Avenue within a year of its completion. Some time prior to 1965, Orchid Dry Cleaners was in the lower level where the service station had been, with the drive-through bay enclosed in a modern glass front. The structure was ultimately razed to make way for the Georgia Avenue–Petworth Metro Station. This image dates to June 1927. (Historical Society of Washington, D.C.)

Built in 1911, Engine Company No. 24 was an excellent example of early-20th-century suburban firehouse design in Washington, D.C. Designed in the Italian Renaissance style by the locally significant architect Luther Leisenring and his partner Charles Gregg, the firehouse became an established landmark in the area. As the first fully motorized fire company in D.C., Engine Company No. 24 was also associated with technological advancements that would change firefighting and firehouse design forever. (Library of Congress.)

Engine Company No. 24 abandoned the use of horses for automotive power in July and August 1912. The company had an automobile piston pumping engine and a combination chemical and hose truck similar to the one shown here. The switch to up-to-date equipment was heralded by the District of Columbia and seen as an achievement in attaining the first-rank status that other major cities were achieving. (Author's collection.)

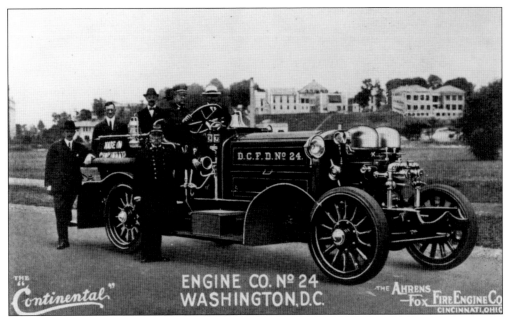

The second of the two motor-driven apparatuses delivered to Engine Company No. 24 in 1912 was this Ahrens-Fox Continental. Ahrens-Fox had just introduced its first gasoline-propelled fire engine in 1911. Before the engine was handed over to the engine house, it underwent stringent testing to ensure its reliability. (Library of Congress.)

By the end of Engine Company No. 24's long history, it had racked up a number of historically significant moments. In addition to its early switch from horse-drawn engines, it was also among the first seven companies to racially integrate. The first shift of African American firemen began on the evening of September 18, 1954. This photograph shows the station's interior during its final years of service. (Library of Congress.)

When laying out the Green Line, Metro planners determined that the station house was located in the middle of the site proposed for the Georgia Avenue-Petworth Metro Station. Despite the historical significance of the structure, Metro decided the structure would be razed. In response to public outcry, a compromise was reached to save the facade. This image was taken on November 29, 1994, as the facade was carefully relocated. (WMATA/Photograph by Larry Levine.)

It was agreed by city and transit officials to use the cost-saving open-pit method to build the Georgia Avenue-Petworth Station in November 1992. Metro officials claimed that using the open pit would save more than the $3 million; this was also the amount they committed to spend on building the new fire station at 5101 Georgia Avenue, about 15 blocks north of the station's former location. This image shows metro construction on New Hampshire Avenue on June 16, 1995. (WMATA/Photograph by Larry Levine.)

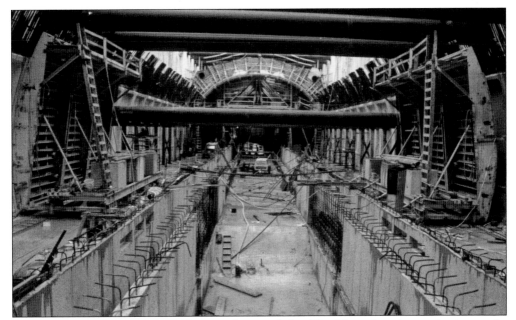

Seen here on April 9, 1996, the underground section below New Hampshire Avenue begins to take shape. Construction of the Georgia Avenue–Petworth Metro was highly disruptive to the area. Among the inconveniences was the diversion of heavy traffic from Georgia and New Hampshire Avenues onto neighborhood streets for the duration of the project. (WMATA/Photograph by Larry Levine.)

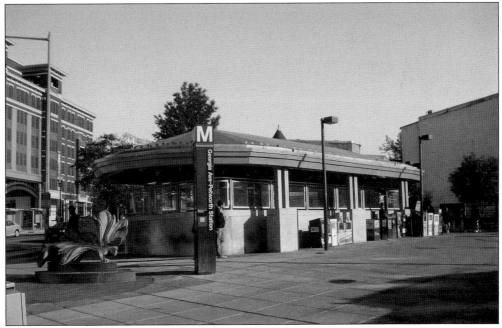

The station officially opened on September 18, 1999. The opening event included speeches from Mayor Anthony Williams, Congresswoman Eleanor Holmes Norton, and Ward 1 councilmember Jim Graham. The opening of the station continued a long history of public transportation along Georgia Avenue. (Photograph by Kent Boese.)

Pictured from left to right in the front on November 12, 2009, are Mayor Adrian M. Fenty, councilmembers Jim Graham and Muriel Bowser. Developer Rob LaKritz and representatives from CVS were also in attendance at the corner of Georgia and New Hampshire Avenues to break ground for the new CVS pharmacy. (Photograph by Kent Boese.)

The $5.2-million Ward 1 Senior Wellness Center, located at the southeast corner of Georgia Avenue and Newton Place, broke ground on October 14, 2009. Above, Mayor Adrian M. Fenty (center), Ward 1 councilman Jim Graham (fourth from left), and others participate in the September 2010 ribbon-cutting ceremony. (Photograph by Kent Boese.)

Six

Putting the Park in Park View
The Soldiers' Home and McMillan Reservoir

The Soldiers' Home has been a gem in the center of the District of Columbia since its founding in 1851. Once an isolated country retreat for retired soldiers and presidents, it gradually became surrounded by some of Washington's original suburbs. As residents moved in, they gradually joined the ranks of tourists as visitors to the grounds.

The Soldiers' Home, which was once open as a courtesy to all wanting to visit or escape the city, quickly became an integral part of daily life in the area. Early real estate developers promoted the merits of the park to prospective homeowners who would live nearby, should they select Park View as their home. Children laughed and played on the grounds, and young adults could while away the time with a picnic or leisurely stroll.

The merits of the home's grounds attracted many to live in the area. Similarly, the McMillan Reservoir provided a park-like atmosphere for rest and relaxation. Due to the openness that once existed with both properties, setting aside additional public parkland was deemed unnecessary as the community developed.

The Soldiers' Home is closed to the public and has been since 1968. The reservoir is similarly closed to the public. While Park View no longer has access to the park that suggested the community's name, its proximity is still a valued and important asset to the neighborhood and the entire area.

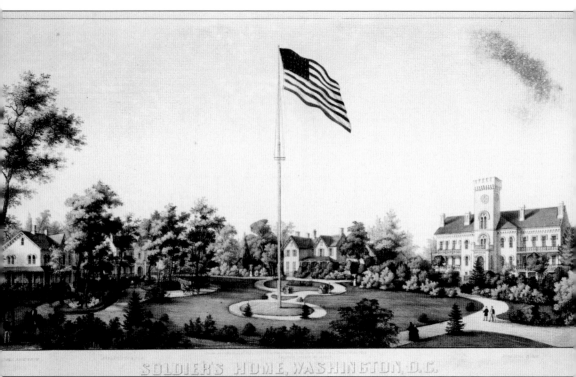

SOLDIER'S HOME, WASHINGTON, D.C.

The Soldiers' Home was created by an act of Congress in 1851, following the Mexican-American War. Its establishment owed a great deal to Gen. Winfield Scott, who had been in charge of troops during the war and was considered an American hero. He returned with $150,000 that was paid to him by Mexico City in return for not ransacking the city. He paid off his troops, bought new supplies, and offered the remaining money to Congress to establish the Soldiers' Home. In 1851, the government purchased George Washington Riggs's home and surrounding farmland to form the core of what is today the Armed Forces Retirement Home. (Library of Congress.)

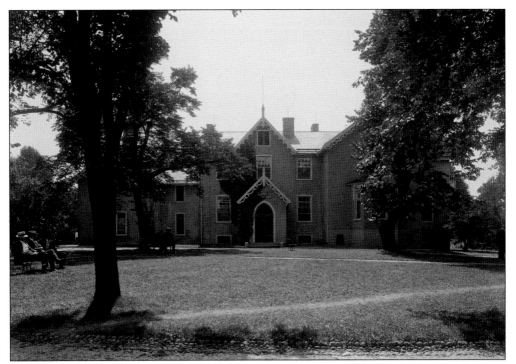

Corn Rigs, built around 1843, was the summer home of George Riggs. After Riggs sold his farm to the Soldiers' Home, the house was first used as a dormitory. Later it was used as the summer retreat for Presidents Buchanan, Lincoln, Hayes, and Arthur. Lincoln finished the final draft of the Emancipation Proclamation while in residence at the cottage. The president also named the building Anderson Cottage in honor of Gen. Robert Anderson, commander of Fort Sumter. Today it is known as Lincoln's Cottage. (Library of Congress.)

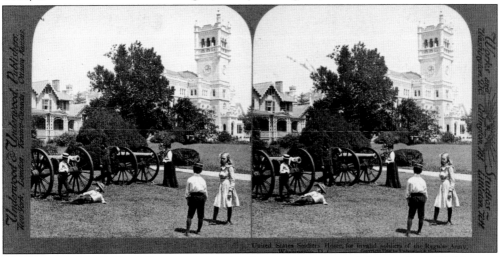

The grounds of the Soldiers' Home, owing to their beauty, openness, and distance from Washington, became an early leisure destination where tourists and residents could relax. Use of the home's grounds increased as Washington society became more mobile and as the area around the grounds became developed neighborhoods. This c. 1903 stereoview was taken near the Anderson Cottage and Scott Building, seen in the background. (Library of Congress.)

Much of the Soldiers' Home's nearly 500-acre reserve was undeveloped but contained roads and paths for veterans and visitors to enjoy though the first half of the 20th century. (Library of Congress.)

Due to the Soldiers' Home's location on some of the highest ground within the District of Columbia, one of the draws of a visit to the grounds was this vista of the Capitol Building to the south. President Lincoln similarly valued this view. (Author's collection.)

While the ground's lakes were a popular destination for visitors seeking relaxation, they also had a darker reputation at the beginning of the 20th century, earning them the unofficial name of Suicide Lakes. This undated photograph shows the lakes as they appeared around 1900. An article in 1896 reported that 30 men had "found the rest that knows no breaking under these waters of Lethe." To prevent further tragedies, the governor of the home detailed a guard to the area. (Author's collection.)

The grounds of the Soldiers' Home were a destination for Washington excursionists. In 1908, they were described as one of Washington's great parks that were well known to motorists. In fair weather, it was not uncommon to find a throng of cars conveying families around the 500 acres of gently rolling grounds. The Soldiers' Home contained more than 16 miles of macadamized roads winding through the acres of oaks and groves of spruce and pine. (Library of Congress.)

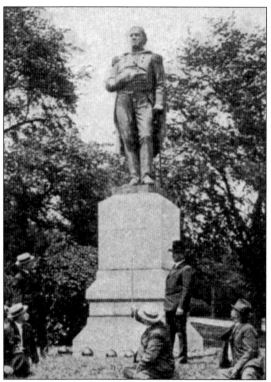

The statue of Gen. Winfield Scott was among the sights on the grounds of the Soldiers' Home. It was sculpted by artist Launt Thompson (1833–1894), who also created the statue of Adm. Samuel Francis Du Pont that once graced Dupont Circle. In 1873, the statue of Scott was erected near the Randolph Street entrance of the grounds. A 1958 article in the *Washington Post* listed it as one of five lesser-known but noteworthy public sculptures in Washington. (Author's collection.)

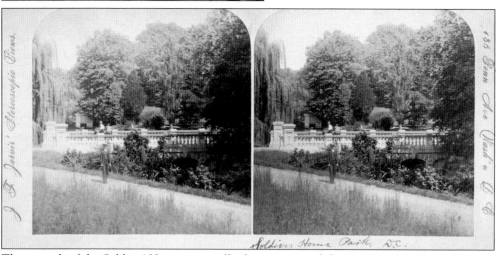

The grounds of the Soldiers' Home, especially the area around the "swan and duck ponds," seen in this c. 1880 stereoview, were an integral part of Park View's early social and leisure life. As the neighborhood was being built and maturing, the grounds were open to the public as a courtesy. Area children would take advantage of the park, young lovers would stroll in its many lanes, and numerous picnics occurred by the water's edge. More formal events were also held near the ponds. Park View's July Fourth celebrations were held there in 1917 and 1918. The grounds played host to thousands of people, young and old, who took part in an Easter egg-rolling contest along the slopes of the ponds in 1926. (Robert N. Dennis Collection of Stereoscopic Views, Miriam and Ira D. Wallach Division of Art, Prints and Photographs, The New York Public Library, Astor, Lenox, and Tilden Foundations.)

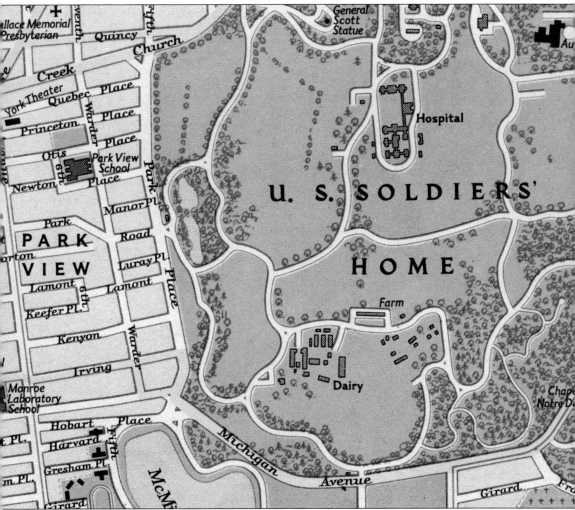

The Soldiers' Home functioned as a self-sufficient community including a hospital, farm, and dairy. The dairy at the Soldiers' Home was located in the southwest section of the 500-acre property, nestled near the McMillan Reservoir and southern Park View. It was a source of pride for both the home and the greater community. A visit by the District's five health department veterinarians in 1907 resulted in one commenting that "the dairy farm at the home . . . is a model in every respect. The herd is one of the finest in the country, and the most modern sanitary precautions are observed." (National Geographic Society.)

This group of buildings was the home of the "First Accredited Herd in the United States." The cattle were registered Holsteins, and the herd consisted of approximately 165 animals, including 5 bulls. The total value of the herd was approximately $50,000 in 1931. The buildings included three cow barns, a maternity barn, a calf nursery, four silos, a creamery, storage barns, an office, and living quarters for the employees. (Author's collection.)

Here is part of the Soldiers' Home herd of registered cattle in 1931. Shown in the left corner, the cow Mary Alexander Barksdale III produced 21,466 pounds of milk as a two-year-old. Her mother produced 23,634 pounds. Shown in the right corner, the bull Ignatius DeKol Piebe was five years old, weighed 2,600 pounds, and was valued at $5,000. (Author's collection.)

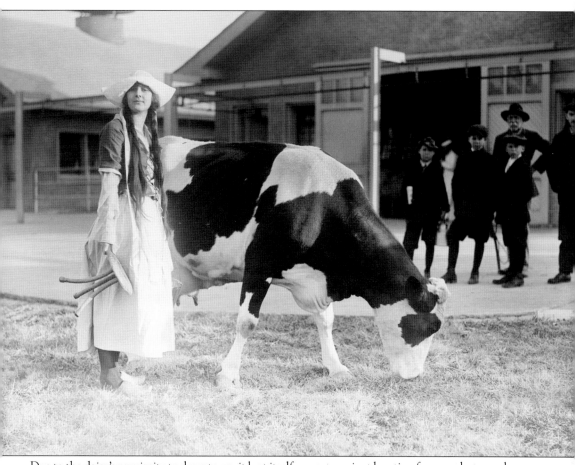

Due to the dairy's proximity to downtown, it lent itself as a convenient location for area photographers needing a rural setting. Here debutante Virginia Eckles is posing with Holstein Bunnie in February 1919. This is one of a series of images captured by photographers Harris and Ewing to promote a Mardi Gras Fete held at the Wardman Park Hotel to benefit the free milk fund for the babies of France. At the event, Courtney Lett's debutantes dressed in milkmaid costumes and wooden shoes. The fund-raiser yielded over $9,000 for the Free Milk for France Fund. (Library of Congress.)

Heavy use by the public took a toll on the Soldiers' Home grounds. One mother felt compelled to write the *Washington Post* in 1924 with her concerns. She described the area around the ponds as nearly dry and full of weeds and mosquitoes. Worse still were the prevailing odors greeting visiting mothers and children. She concluded by accusing the District Department of Health of appearing more concerned about weeds on residential lawns than about conditions at Soldiers' Home Ground Park. Above is a photograph of the area in better times. (Author's collection.)

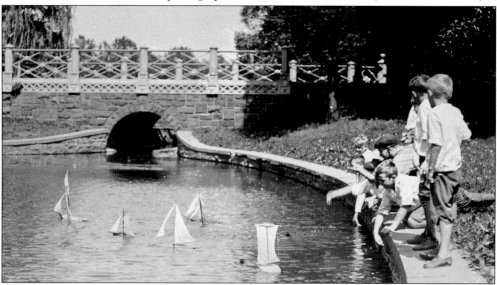

The summer pleasure of sailing boats on the duck pond came to an end on August 20, 1924, when workers began erecting a 6-foot-high wire fence around the body of water. Children by the scores argued with the workmen charged with installing the fence. According to representatives of the Soldiers' Home, the fence was needed due to the number of youngsters who had fallen into the water. Soldiers' Home guards offered the following alternative explanation: too many careless picnickers had cluttered the clear, sparkling water with the remains of their lunches. (Library of Congress.)

When retired M.Sgt. Nelson Gilchrist of 645 Irving Street was photographed fishing at the Soldiers' Home's duck pond in 1963, the days of public access were coming to a close. The civil unrest of 1968 resulted in the grounds being closed to all but the retired soldiers living there. (Courtesy of the Washingtoniana Division, D.C. Public Library.)

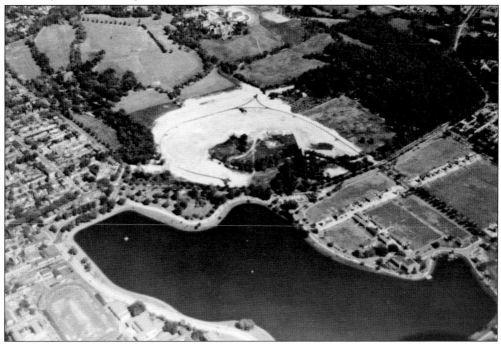

In December 1953, the Soldiers' Home began closing its southern gates to allow excavators to clear ground for the $17.5-million Washington Hospital Center. This image shows the property after the grounds had been cleared of 16 farm buildings and one residence. Construction of the new hospital was completed in 1958 and combined the Emergency, Episcopal, and Garfield Hospitals. (Courtesy of the Washingtoniana Division, D.C. Public Library.)

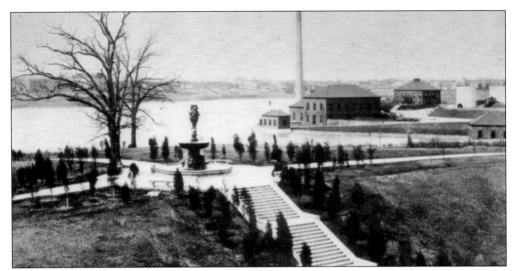

The Washington Reservoir was renamed after Michigan senator James McMillan (1838–1902) in 1907. It once served as a place where Washingtonians picnicked, strolled, and relaxed. Though different in character from the neighboring Soldiers' Home, the park was every bit as important to the communities around it as a place to rest and rejuvenate. Among the landscape features found to the west of First Street, NW, near the Channing Street intersection, was a fountain and statue honoring Senator McMillan, which could only be reached by a staircase. (Paul K. Williams, Kelsey, and Associates/National Archives.)

Crowning the park was a pink granite fountain designed by Herbert Adams and Howard Platt. It was dedicated in 1913 as a memorial to Sen. James McMillan. Featuring three nymphs representing faith, hope, and charity, the monument was funded by contributions from every county in Michigan. (Paul K. Williams, Kelsey, and Associates/National Archives.)

The slow sand-filtration site was a model facility. It continued to serve the city until 1986. In the following year, ownership of the land was transferred to the District, and the site has been abandoned since that time. (Author's collection.)

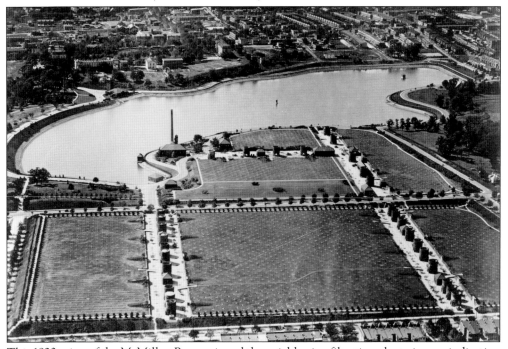

This 1920s view of the McMillan Reservoir and the neighboring filtration plant gives an indication of the massive scale of the facility. The view is from North Capitol Street, looking toward the west. (Library of Congress.)

www.arcadiapublishing.com

Discover books about the town where you grew up, the cities where your friends and families live, the town where your parents met, or even that retirement spot you've been dreaming about. Our Web site provides history lovers with exclusive deals, advanced notification about new titles, e-mail alerts of author events, and much more.

Arcadia Publishing, the leading local history publisher in the United States, is committed to making history accessible and meaningful through publishing books that celebrate and preserve the heritage of America's people and places. Consistent with our mission to preserve history on a local level, this book was printed in South Carolina on American-made paper and manufactured entirely in the United States.

This book carries the accredited Forest Stewardship Council (FSC) label and is printed on 100 percent FSC-certified paper. Products carrying the FSC label are independently certified to assure consumers that they come from forests that are managed to meet the social, economic, and ecological needs of present and future generations.

Find Your Place in History.